Jonathan Richardson
By Himself

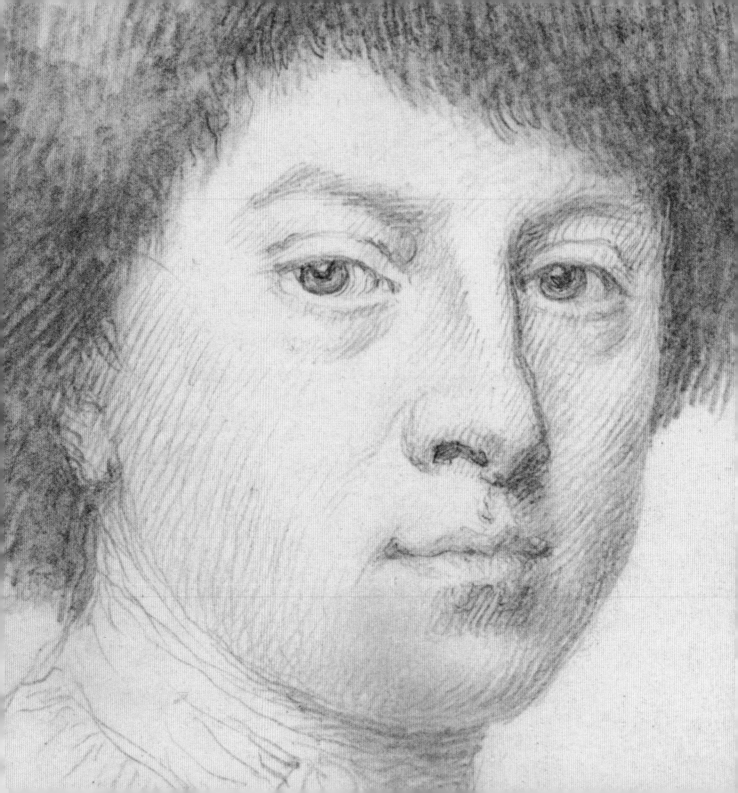

Jonathan Richardson
By Himself

Susan Owens

First published to accompany
Jonathan Richardson *By Himself*

The Courtauld Gallery, London, 24 June – 20 September 2015

The Courtauld Gallery is supported by the Higher
Education Funding Council for England (HEFCE)

ISBN 978 1 907372 84 1

British Library Cataloguing in Publication Data

A catalogue record for this book is available from the British Library

Produced by Paul Holberton publishing
89 Borough High Street, London SE1 1NL
www.paul-holberton.net

Designed by Laura Parker
www.parkerinc.co.uk

Printing by Gomer Press, Llandysul

FRONT COVER: Detail of *Self-portrait*, 1728 (cat. 1)
FRONTISPIECE: Detail of *Self-portrait at the age of thirty*, 1735 (cat. 11)
PAGE 8: Detail of *Self-portrait*, 1728 (cat. 2)

Acknowledgements

My first thanks are to those at the Courtauld who gave me the opportunity to curate this exhibition and continued to offer support and encouragement, Ernst Vegelin van Claerbergen and Stephanie Buck. I would also like to offer warm thanks to David Solkin for his advice and generous loan of a rare counterproof from his own collection; to Kate Edmondson for sharing her expertise on drawing media; to Rachel Sloan for swiftly answering numerous questions; and to Julia Blanks, George Mogg, Chloe Le Tissier and Karin Kyburz for their valuable administrative support. I am especially grateful to Bryony Bartlett-Rawlings for her generous help with research.

Elsewhere, I am grateful to the following for their help: Lisa Coombes, Catherine Daunt, Gillian Forrester, Colin Harrison, Dana Josephson, Amy Marquis, Lindsey McCormick, Eisha Neely, Maria Singer, Kim Sloan and Jennifer Tonkovich.

I offer warm thanks to Bijan Omrani, who generously translated the Horatian inscriptions on the drawings, and to James Hall for his insightful comments on the cultural context of Richardson's self-portraits.

Anyone working on Richardson owes a substantial debt to the pioneering work carried out by Carol Gibson-Wood, whose monograph and scholarly articles are indispensible.

Finally, special thanks, as ever, to my husband Stephen Calloway.

Susan Owens

Supporters

Jonathan Richardson By Himself is sponsored by

**The International Music and Art Foundation
Lowell Libson Ltd**

The Gilbert and Ildiko Butler Drawings Gallery was made possible by a major grant from Gilbert and Ildiko Butler, with further generous support from:

Anonymous, in memory of Melvin R. Seiden
The International Music and Art Foundation
Lowell Libson Ltd
Diane Allen Nixon
Niall Hobhouse and Caroline Younger
Andrea Woodner
Elke and Michael von Brentano
Tavolozza Foundation – Katrin Bellinger
The Samuel Courtauld Trust

Foreword

Jonathan Richardson By Himself is the fourth project to be presented in the new Gilbert and Ildiko Butler Drawings Gallery since its opening in January 2015 and the first to feature a publication and loans from other institutions. The drawings gallery was conceived to meet two needs: in the first place to provide The Courtauld with a purpose-built facility for sharing with the public selections from its outstanding collection of some 7,000 drawings; and secondly to enable, both physically and conceptually, projects which might not find a home in the main exhibition programme. The recognition that such projects could be amongst the most original and diversely rewarding that the Gallery might undertake was a powerful motivation. The drawings gallery programme is unencumbered by the many expectations which attend larger exhibitions and is therefore free to search out the overlooked and to take some risks; in so doing we hope that it will contribute to the development of fresh perspectives in the study and appreciation of drawings.

The Courtauld is delighted to have the opportunity of this inaugural publication to thank the donors who embraced and supported the new gallery's rather singular aims. Gilbert and Ildiko Butler provided the enormously generous enabling grant and were soon joined by others who recognised the potential value of the scheme and its particular relevance in the context of a leading university art museum such as The Courtauld Gallery. We are enduringly grateful to them all and we look forward to sharing with them the journey of discovery that we have so happily embarked upon.

It was always our intention that the drawings programme should include projects which, supported by a publication, would share significant new research or thought, and focus attention on particular episodes or aspects of the history of draughtsmanship. *Jonathan Richardson By Himself* sets the template for this approach and does so at a very high standard. I am enormously grateful to Susan Owens for so expertly and engagingly leading this project from start to finish. The remarkable story she unfolds in this catalogue speaks profoundly about the unique possibilities of drawing as medium.

My warm thanks go to the Trustees of the International Music and Art Foundation and to Lowell Libson Ltd for jointly sponsoring this exhibition. The freedom to range outside the mainstream is a luxury that few museums could permit themselves without such philanthropic support. Finally, I would like to thank our friends and colleagues at the Prints and Drawings Department of the British Museum and at the Fitzwilliam Museum, the National Portrait Gallery and Cambridge University Library for their generous loans to this project.

Ernst Vegelin van Claerbergen
Head of The Courtauld Gallery

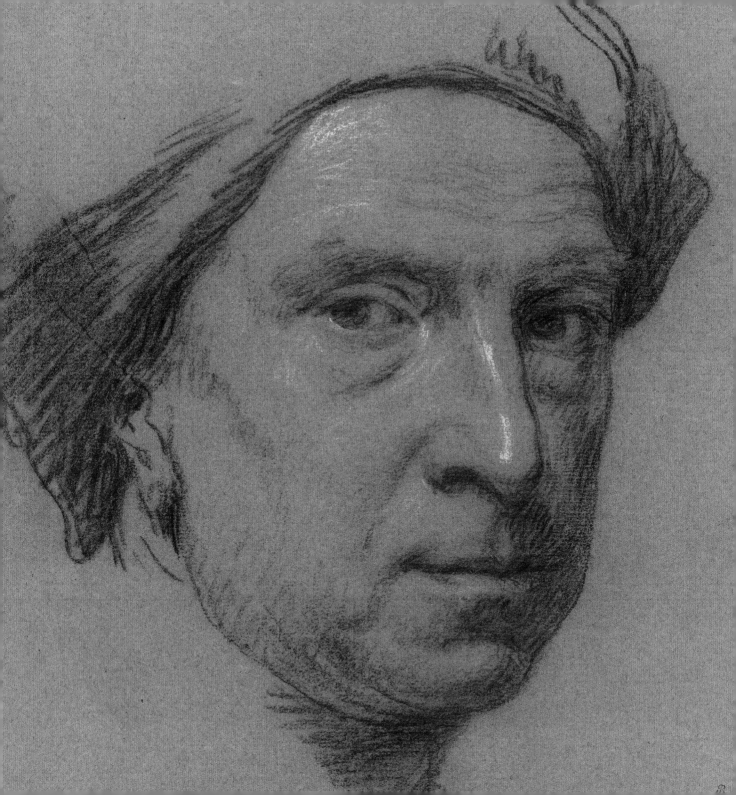

Introduction

When the collection of drawings that had belonged to Jonathan Richardson the Younger was sold at auction in 1772, there was a revelation. Interspersed with Richardson's Old Masters were well over a thousand drawings by his beloved father, the portrait painter Jonathan Richardson the Elder (fig. 1), brought into the public eye for the first time.[1] Over 650 of these were portraits, of which a substantial proportion are described as self-portraits.[2] Although many of these have again disappeared from view, today around fifty-five self-portrait drawings by Richardson are known.

Few people outside the elder Richardson's immediate circle of friends can have known of the existence of these works. They were not made for sale, or as preparatory studies for paintings – in fact, drawing seems not to have played an important part in his studio practice, and Richardson seems in most cases to have worked directly on to the canvas.[3] Instead, they were private, independent drawings, apparently made entirely for their own sake. Horace Walpole, who purchased some of Richardson's portraits at the sale, remarked that "after his retirement from business, the good old man seems to have amused himself with writing a short poem, and drawing his own or son's portrait every

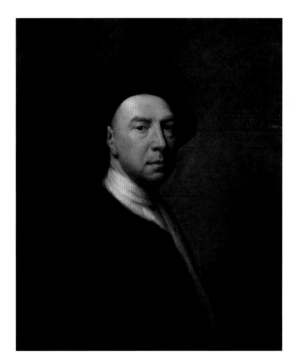

FIG. 1
Jonathan Richardson
Self-portrait, 1729
Oil on canvas, 73.7 x 62.9 cm
National Portrait Gallery,
London, inv. no. 706

day".[4] Although Walpole exaggerated the frequency with which they were produced (it was probably every week or two), the sheer quantity of these self-portraits was still staggering. Using different media and working sometimes on large sheets of paper and at others on small vellum leaves, Richardson depicted himself in a range of moods and guises: in some he subjected his ageing face to unflinching scrutiny, while in others he projected a suave and sophisticated persona. Made regularly over a period of years and usually inscribed with the precise date they were made, these self-portraits amount to nothing less than a visual diary. They were unprecedented in England – and it was not until the late twentieth century and the rise of video art that self-portraiture of a comparably serial nature was attempted.

Richardson had risen from modest beginnings – he was the son of a London silk weaver – to become one of the most successful portrait painters of his generation. His sitters included many luminaries of the late Stuart and early Georgian era – aristocrats Sir Robert Walpole and Lady Mary Wortley Montagu, authors Alexander Pope, Matthew Prior and Sir Richard Steele, the sculptor Michael Rysbrack, the artist Sir James Thornhill and the great physician-collectors Sir Hans Sloane and Dr Richard Mead. According to his son, Richardson had twice been "powerfully invited" to be the King's Painter, but had refused because of his "aversion to what he called 'the slavery of court dependence'".[5] He also wrote influential books on art theory and connoisseurship, and was a director, from its foundation in 1711, of the first formal academy of art to be established in England. On Richardson's death in 1745, the chronicler of the early Georgian art world George Vertue remarked that "this was the last of the Eminent old

painters. that had been cotemporyes in Reputation – Kneller Dahl. Jarvis & Richardson for portrait painting".[6]

As far as we know, Richardson began in earnest to make self-portrait drawings in 1728, a couple of years before his semi-retirement from professional life. Over the following years he regularly drew his own portrait and that of his eldest son, as well as making numerous small drawings of friends and acquaintances. The latest date on a self-portrait drawing is 1739, although Richardson continued to draw portraits of others into the early 1740s.

For his self-portrait drawings Richardson habitually used either of two sets of media. One of these was chalk – principally black heightened with white, sometimes with the addition of red – mostly on large sheets of blue paper (see cat. 1, 2, 7, 12). Chalk was a versatile medium, sufficiently dense to be sharpened to a point for linear detail, but soft enough to be ideal for modelling. The drawings in this group mostly show Richardson as he would have dressed when he was at home: in an era when gentlemen wore wigs as part of formal dress and as a consequence shaved their heads, he normally wears a soft cap but occasionally has his head uncovered. As well as for drawings of himself, he also used chalks to make portraits of his son (see cat. 19 and 20), but only rarely used this medium for portraits of others. These chalk drawings are mostly large, with the head rendered at sight size.

Richardson also made numerous self-portrait drawings in the more delicate medium of graphite; these were usually on small sheets of fine vellum, a smoother drawing surface than paper (see cat. 5, 6, 8, 9, 10, 11, 13, 15). He used graphite for a wider range of self-portraiture than chalks: sometimes he presented himself in inventive and humorous ways, such as in profile, *all'antica*, as though on the face of a coin or medal (see cat. 9), or crowned with bay leaves in the

guise of a celebrated poet (see cat. 5). In some he copied his image from oil paintings made decades earlier, in order to recall his appearance as a younger man (see cat. 10 and 11). However, many other graphite-on-vellum drawings have a direct, informal air which suggests that they were drawn from the life and, as in the chalk drawings, show the artist wearing a soft cap rather than a formal wig or with his head uncovered (see cat. 13).[7] Graphite on vellum is also the medium Richardson most frequently used for the many small portraits of friends, acquaintances and historical figures he made for his own collection.

He also made many pen-and-ink portrait sketches, most of which are of a sketchy and even perfunctory nature, and are apparently preparatory stages in the production of the more refined drawings on vellum. In addition, Richardson made at least five self-portrait etchings (see cat. 16), in at least one case working from preparatory drawings.[8]

Richardson used materials creatively, and, although he appears to have employed graphite rather than chalks for his most playful *jeux d'esprit*, the portraits in his two principal sets of media share much common ground. If anything, his choice of medium was probably dictated by location; if he apparently confined large sheets of paper and potentially messy chalks to his home, it was probably because pen and ink, and small neat leaves of fine vellum and graphite pencils, were easily portable and more appropriate to friends' drawing rooms.

A *kind of an additional life*

It was not just portrait drawings that occupied Richardson during these years of semi-retirement; another important activity – even a parallel one – was writing poetry. "A kind of an additional life" – this was how Richardson, an early riser, described the hours he spent thinking and writing poems before the day began.[9] According to his son, "He rose very early, in the summer often at four, seldom later than six even in winter, for he had his fire laid, and a rush-light burning, to kindle it himself, with two large candles placed. These hours he used to call 'his own'."[10] Richardson himself described his daily routine in the following words: "I wake early, think; dress me, think; walk, think; come back to my chamber, think; and as I allow no thoughts unworthy to be written, I write. Thus verse is grown habitual to me."[11] Although we do not know if Richardson also made his self-portraits in these early morning hours, he certainly applied a similar degree of self-scrutiny to the drawings as is found in his poems. Like his portrait drawings, Richardson's poems chiefly date from the latter part of his life; also like his drawings, they were produced frequently and almost always dated precisely.

Richardson's poems were edited by his eldest son but only published after the latter's death by James Dodsley in 1776 as *Morning Thoughts, or Poetical Meditations, Moral, Divine and Miscellaneous, Together with several other Poems on various subjects* (fig. 2). The poems collected in the volume were, essentially, personal and Richardson had not wished them to be published in his lifetime. However, the inclusion of a preface written in part by Richardson himself indicates that he had contemplated and was willing for a selection of his poems to be published after his death. The 240 chosen for the book were, Richardson Junior notes, "part of a much larger number intended for publication", and indeed *Morning Thoughts* is described on the title page as Volume I, although the further volume, or even volumes, that this implies never appeared.[12] *Morning Thoughts* was presumably printed in a small edition and is, today, an exceptionally rare book.

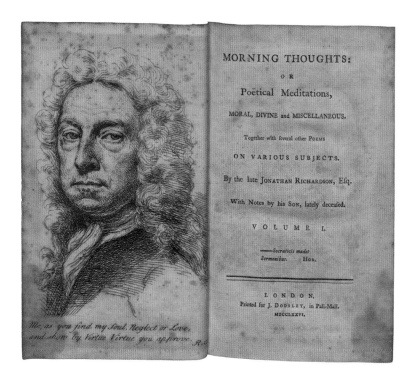

FIG. 2

Jonathan Richardson, *Morning Thoughts, or Poetical Meditations, Moral, Divine and Miscellaneous, together with several other poems on various subjects*, edited by Jonathan Richardson the Younger, London: printed for J. Dodsley, 1776 Cambridge University Library, 7720.d.1375

Richardson wrote what he considered to be two types of poem, which are divided into separate sections in the published volume. The 'Morning Thoughts', occupying the first part of the volume, belong to a relatively short time-span during Richardson's years of semi-retirement, and were composed between 1732 and 1736. Richardson limited the subject-matter of these poems to a number of recurrent themes – observations of the dawn; reflections on the swift passage of time and his own ageing; examination of his moral integrity; and his eagerness to begin the day ahead. The verses which fill the latter part of the volume were composed over a greater time-span, between 1704 and 1735. They have a more varied emotional register; some are witty and epigrammatic, while others poignantly lament the writer's widowhood. For the era in which they were written, they are extraordinary for their direct and unguarded manner of expression.[13] These poems show more formal variation than the 'Morning Thoughts', and range from pithy couplet to multi-stanza lyric. As with the portrait drawings, both types of poem are usually dated specifically to the day, occasionally even to the hour.

Despite his willingness for his verses eventually to be published, Richardson did not regard them as polished works of art; in his preface he instructs the reader: "I call these, *Thoughts*, not poems; consider them accordingly".[14] For Richardson, the value of writing poetry lay in its capacity to engender introspection and self-improvement. He noted in particular its effect on the quality of his thought, which he considered to be "greatly improved and enlarged by writing ... verse hath still a greater

advantage, it gives a compass, and elevation, and variety, a greatness and grace, which prose sits down satisfied without".[15] The practice of self-portraiture demanded a similar degree of disciplined self-examination, and it appears that Richardson regarded the two art forms in a similar light (see cat. 16). Poems and portraits alike provided an arena for this extraordinary man to shape – and to express – his thoughts and moods.

All my swift successive nows

So what was the purpose of the self-portrait drawings? This is not an easy question to answer, because Richardson's surviving correspondence contains no direct reference to them, nor does he mention them in his published works of art theory. His pronouncements on portraiture generally, however, provide a context:

> a portrait is a sort of General History of the Life of the Person it represents, not only to Him who is acquainted with it, but to Many Others, who upon Occasion of seeing it are frequently told, of what is most Material concerning Them, or their General Character at least.[16]

In this account, the portrait is expected to do much more than capture a particular moment. Charged with significance, it must be a vehicle for expressing a biographical narrative. But here Richardson was talking about oil paintings – which, in the hierarchy of media understood at the time, enjoyed a far more elevated status than drawings. Richardson had a vested interest in aggrandising the portrait painting, and argued in his theoretical works that portraiture was capable of attaining the depth and gravitas of 'history painting', the most esteemed genre of

works on historical, religious or literary themes. The fact that Richardson's self-portrait drawings are nearly all dated precisely places them in a different category – each is not a 'General History' but, rather, a particular one. These drawings allowed Richardson to explore individual facets of character that – in the light of his theories – the oil painting ought to aspire beyond. Richardson's belief that the portrait painter should endow his subject with a poise he or she might assume "when one comes into Company, or into any Publick Assembly, or at the first Sight of any particular Person" is, again, the opposite of what the maker of private self-portrait drawings might do.[17] Fewer rules were attached to drawing, with the result that it offered a greater freedom of expression – and among its advantages was the capacity to capture the fleeting moment, or "all my swift successive nows", in Richardson's own evocative phrase.[18]

In his retirement, time – how to make the most of it, and its passing – became an important theme for Richardson. On the back of one of the self-portraits an inscription apparently in the hand of Jonathan Junior reads *Tranquilla Senectus*, a quotation from the Roman poet Horace, meaning 'peaceful old age'.[19] But this might seem to imply a relaxation from activity, which was alien to Richardson's character. Elsewhere his son notes that one of Richardson's most common phrases was 'As fast as possible', recalling that it was "an expression so frequent with him, that my dear mother used to make herself and him, now and then, merry with rallying him on this perpetual proof of the activity of his spirit".[20] Many titles in *Morning Thoughts* indicate the importance of activity to the author: 'Busy'; 'Fill Time Well'; 'Be Doing'; 'Early Impatience to be in Action', and in one poem Richardson writes of "Detesting a dishonour'd idleness".[21] And indeed, the context of the quotation, from Horace's *Satires*, complicates the apparently

simple sentiment; rather than calm acceptance, the phrase actually relates to determined activity: "whether peaceful old age awaits me, or if death hovers about me with black wings, rich, poor, at Rome or, if chance wills it, an exile, whatever complexion my life takes on, I will write" – write, that is, as a critical observer of life.[22] What the inscription records is the classically educated Jonathan Junior's tribute to his father's energetic spirit.

Richardson's poems contain much biographical information that sheds light on his activities and opinions. In a poem addressed to his friend Sir Berkeley Lucy, 'Leisure with Dignity', he describes how, in retirement, he "employs" his "leisure hours". He explains that, now no longer a professional portraitist, he enjoys practising his art all the more: "Not mercenary now, the art belov'd, / Companion, friend, with native lustre shines".[23] Richardson tells Sir Berkeley that, freed from the constraints of a busy commercial practice, he is able to indulge his love of drawing for its own sake – and, as a portraitist, it is hardly surprising that he chose to concentrate on the face – his own and those of others.

The other side of the coin of his preoccupation with activity, however, was Richardson's acute awareness of the passing of time. He may have been drawn to writing and drawing because of his compulsion to 'Fill Time Well', but once engaged with these pursuits darker reflections often came to the surface. The poem of that name begins: "My life, each morning when I dress, / Is four and twenty hours less; / Incessantly the current flows, / And ev'ry hour an hour goes" – an arresting description of how he felt the time he had left to live to be ticking inexorably away.[24] In late autumn and winter of 1733 he was particularly beset by melancholy reflections in the wake of the apparent breakdown of a close friendship, and returned to the theme of passing time, for

example in 'To the Clock', in which he addresses the inexorable march of hours: "O Strike no more, thou strik'st too fast, / Since last thou struck'st, an hour is past".[25] The theme of mortality also emerges in his self-portrait drawings, perhaps most powerfully in a portrait of October 1735 (cat. 12) in which Richardson dwells on his ageing face. The portraits do two related things: they make time stand still by their capacity to record the fleeting moment; but they also document its effects. And in the tradition of the *memento mori* image, they allow Richardson to contemplate the fact of his own ageing.

To raise and mend my soul I meditate

In a poem entitled 'Why I Write', which Richardson composed on 19 December 1734, he explains:

> Though few approve, I'll write my thoughts, but why?
> Indeed, ye nice, 'tis not to humour you;
> I write to please myself, I not deny,
> And to give pleasure to the friendly few.
> And not alone to please, though worthy that,
> More worthy yet is my sincere design;
> To raise and mend my soul I meditate,
> And happy thou, if that intent be thine.[26]

If we understand ideas expressed in his poems also to be motivating factors for his self-portraits, then drawing his own countenance can be seen as a contemplative process through which Richardson reflected on his character and state of mind. Drawing was a discipline that demanded focused concentration on his entire self – not just on his features, but on his moral values too. For Richardson, the self-scrutiny necessary to self-portraiture was not mere passive observation; it could – and should – lead to greater self-knowledge. Richardson's search for this goal had a

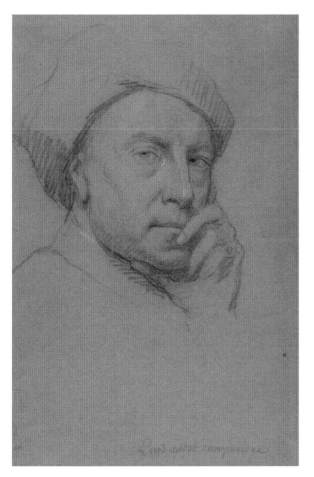

classical framework. The quotation from Horace that Jonathan Junior eventually placed on the title page of *Morning Thoughts*, "*Socraticis madet Sermonibus*" (steeped in the Socratic dialogues), evokes Socrates's own lively quest for self-knowledge, summed up by his famous assertion that "the unexamined life is not worth living" – a maxim that applies equally to Richardson's investigative project of self-portraiture.[27]

The search for moral self-awareness through the medium of self-portraiture, and the classical framework of this endeavour, is vividly illustrated by a work that, unusually, bears a Latin inscription written by Richardson himself, rather than his son (fig. 3).[28] Below the portrait, which shows him wearing a thoughtful, even shrewd expression, he has written the words *Quod adest compenere*, a contraction of "*Quod adest memento componere aequus*", from Horace's *Odes*, meaning 'remember to settle the problem at hand with a level spirit'.[29] This Horatian memorandum-to-self suggests that Richardson regarded the process of self-portraiture as an opportunity to reflect on his character and actions, to control his mood and to consider ways to tackle immediate problems.

Dear resemblances

Richardson himself tells us that, during these contemplative years of semi-retirement, he spent time in his room reminiscing about his life and reviewing its events and personae. Towards the end of a narrative poem describing a journey from Whitchurch in Hampshire, where he had been staying with a friend, back along the course of the Thames to his home in London, Richardson describes his way of life:

> Now to my room and solitary chair
> I haste, and all my soul is busy'd there;

There night and morn I meditate and read,
Review my thoughts, and every word and deed,
My hopes and fears, my joys and griefs renew'd,
My passions are encourag'd, or subdu'd;
The pleasing scenes of my past life again
I there enjoy, and triumph o'er the pain,[30]

Self-portraits were part of this process of review, and one of the ways in which Richardson reflected on his "past life" was by occasionally representing himself in drawings as a younger man, creating a sort of visual autobiography: an inscription on the back of a graphite-on-vellum drawing made in 1735 (cat. 10) records that it was copied from an oil painting executed in 1692, a self-portrait (untraced) dating from shortly before his marriage.

But there is a broader context to the these self-portraits, because another of the ways in which Richardson addressed his past and fleshed out his visual autobiography was by creating portraits on vellum or paper to which he referred in a letter as "my Collection of the Portraits of my Friends".[31] Some of these were copied from existing paintings while others were drawn from the life or from preparatory pen-and-ink sketches.

Richardson's most frequent subjects, after himself, were his eldest son and his great friend the poet Alexander Pope. Jonathan Junior remained unmarried and continued to live in his father's house. The two men were very close, sharing literary and artistic interests and collaborating on books; Richardson regarded his son's talents and experience as complementary to his own, so much so that he even referred to him as "My Other Self".[32] A great many surviving drawings both in chalk and in graphite record Jonathan Junior's features, and even after Richardson Senior had, apparently, stopped making self-portraits he continued to draw his son;

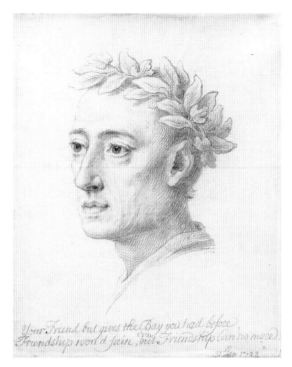

FIG. 4
Jonathan Richardson
Alexander Pope, 1733/34
Graphite on vellum, 168 x 136 mm
The British Museum, London,
1902,0822.17

touchingly, he is portrayed in what was perhaps the last portrait drawing Richardson made, dated August 1743.[33]

Richardson portrayed Pope numerous times, sometimes in carefully finished portraits (fig. 4), at others in informal sketches evidently made as they sat and talked. He also made drawings of other members of his social circle such as the artist Sir James Thornhill, the physician and collector Sir Hans Sloane and the antiquaries George Vertue and Martin Folkes. These portraits were created in the context of friendship, something that is particularly evident in a

group of portraits Richardson made in the early 1730s of Catherine Knapp, whom he met at Shardeloes in Buckinghamshire, the house of a mutual friend. Mrs Knapp shared Richardson's love of poetry, and he addressed a number of playful and flirtatious poems to her; she also inspired some of his most delicate and lively graphite-on-vellum drawings (fig. 5).

Richardson regarded the portrait as having a commemorative function, writing in his *Essay on the Theory of Painting*:

> And thus we see the Persons and Faces of Famous Men, the Originals of which are out of our reach, as being gone down with the Stream of Time, or in distant Places: And thus too we see our Relatives and Friends, whether living or dead, as they have been in all the Stages of Life. In Picture we never dye, never decay, or grow older.[34]

This conviction of the importance of portraiture in recording personalities and making absent friends and relatives present, central to humanist thought, had assumed a particular importance to Richardson's contemporaries. At this time there was a growing appetite for engraved portraits in England, for which Vertue did much to cater with the prodigious number of prints he engraved and published of poets, kings and other illustrious figures. Over the next decades the collecting of portrait heads became a popular pursuit; it was Richardson's innovation to create his own personal portrait gallery.

Describing his room at home, Richardson remarked on his surroundings:

> As here I sit, and cast my eyes around,
> The history of my past life is found,
> The dear resemblances of those, whose names
> Nourish and brighten more the purest flames.[35]

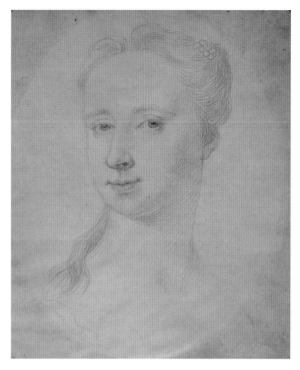

FIG. 5
Jonathan Richardson
Catherine Knapp, 1731
Graphite on vellum, 141 x 117 mm
Private collection

Richardson is clearly referring to portraits here, and, as he seems to be speaking of his bedroom, one would expect the works to be, in the main, drawings or prints rather than oil paintings, which suggests that he had framed a selection of his most finished vellum drawings for display. This was the very time at which framing and hanging prints and drawings became popular; noting that they "are an agreeable Ornament for Rooms", Vertue offered his portrait prints for sale "in neat black Frames and Glasses".[36] However, given the numbers of his portrait drawings, and the evidence of ruled borders on some of them, which

are consistent with those he added to other works in his collection, it is likely that Richardson arranged the majority in albums, which is how his Old Master drawings were housed.[37]

Richardson did not limit his scope to friends and acquaintances; he also made numerous portraits of historical figures including John Milton, Charles I and Oliver Cromwell. Usually on small sheets of paper or vellum, these were either copied from works in his own extensive collection or from those of his friends. He made portraits of Milton from three main sources – a pastel drawing by William Faithorne that Richardson had acquired from Vertue in the early 1730s; a portrait miniature by Samuel Cooper; and, most frequently, a cast of a bust attributed to Edward Pearce that belonged to Vertue.[38] Richardson owned a plaster cast of Bernini's bust of Charles I – an interesting rarity, because the original had been destroyed in the Whitehall fire of 1698 – from which he made a number of drawings.[39] The sale catalogue of Richardson's collection lists a bust of Cromwell, which also served as a model; Richardson clearly took the opportunity to record the features of these famous men from three-dimensional representations where possible.[40] That these little drawings exist in such large numbers suggests that, in repeatedly scrutinising the faces of these figures, Richardson sought to attain a greater understanding of their characters – which was, without doubt, a central motivation in drawing his own.

Richardson's collection was a source of inspiration in another important way. Unusually for the time in England, he greatly admired Rembrandt as a draughtsman and owned a large group of drawings and etchings by him, the most extensive then in England. His collection included at least one of Rembrandt's intense and introspective self-portrait etchings, which he stamped in the bottom right-hand

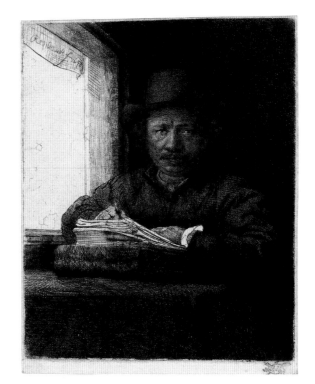

FIG. 6
Rembrandt van Rijn
Self-portrait drawing by a window, 1648
Etching, drypoint and burin,
160 x 130 mm
The British Museum, London, F,4.32

corner with his collector's mark (fig. 6).[41] Rembrandt's example both as an inveterate self-portraitist and as a compulsive draughtsman must surely have set Richardson on his own course, motivating him to explore the capacity of the portrait to track the face over time, recording its ageing and the shades of its changing moods. Above all, Richardson knew that it was through drawing – the medium he loved, and that he described as being "the very Spirit, and Quintessence" of art – that he could realise his extraordinary project.[42]

Notes

1 *A catalogue of the large and capital collection of prints and drawings of Jonathan Richardson Esq* (London 1772); in 'The Art World in Britain 1660 to 1735', at http://artworld.york.ac.uk; accessed 1 July 2014.

2 It is not possible to enumerate the self-portrait drawings in the 1772 catalogue because the descriptions of lots are often vague; for example lot 24 of day two of the sale: "Twelve heads by Richardson, of himself and others"; and lot 21 of day six: "Ten heads of Mr. Richardson and others, names on the back, vellum, by ditto [I.R. Sen]". Counting etchings alongside drawings, the total number of portraits by Richardson rises to approximately 900 (although many of the prints would have been multiple impressions from the same plate).

3 See Gibson-Wood 2000, p. 65.

4 Walpole 1782, IV, p. 38.

5 Note by Jonathan Richardson Junior at the end of 'Shunning Courts', in Richardson 1776, p. 281. When Richardson was pressed to execute a portrait of Frederick Prince of Wales, Jonathan Junior noted with satisfaction that "the last came home to sit to him": ibid.

6 Vertue 1933–34, III, p. 125.

7 I no longer accept the prevailing theory that none of the graphite-on-vellum drawings was drawn *ad vivum* (as suggested by Noon 1979, p. 33; Gibson-Wood 1994, p. 209; Gibson-Wood 2000, p. 123; and Owens 2013, p. 57). See Owens 2015a, forthcoming.

8 A pen-and-ink self-portrait of 1736 (Yale Center for British Art, New Haven, B1975.4.673) and a schematic graphite drawing of 1738 (in Cornell University Library, Ithaca, Hibbert-Ware album, no. 4600) both appear to be preparatory sketches for a self-portrait etching of 1738 (see, for example, British Museum,

London, 1850,0810.34). See Bartlett-Rawlings 2015 (forthcoming)

9 Richardson 1776, p. 2.

10 Note by Jonathan Richardson Junior at the end of 'Leisure with Dignity', in Richardson 1776, p. 286.

11 Richardson 1776, p. 3.

12 Richardson 1776, p. xv.

13 See Lonsdale 1985, p. 191.

14 Richardson 1776, p. 4.

15 Richardson 1776, p. 2.

16 Richardson 1719, I, p. 45.

17 Richardson 1715, p. 179.

18 'My Manner in Writing', Richardson 1776, p. 126.

19 *Self-portrait*, 1733, black, red and white chalk on blue paper, British Museum, London, 1902,0822.40. Horace Walpole, who bought the drawing at the 1772 sale, inscribed the drawing on the recto: *His son has written on the back Tranquilla Senectus.*

20 Note by Jonathan Richardson Junior at the end of 'On My Late Dear Wife', in Richardson 1776, p. 174.

21 'A Better Picture', in Richardson 1776, p. 132.

22 Horace, *Satires*, II, I, 57. I am grateful to Bijan Omrani for his translation and contextualisation.

23 Richardson 1776, p. 285.

24 Richardson 1776, p. 28.

25 Richardson 1776, p. 35.

26 Richardson 1776, pp. 283–84.

27 Plato, *Apology*, 38A.

28 According to his son, Richardson Senior was "entirely ignorant" of Greek and Latin: Richardson 1776, p. 168; Richardson, however, benefitted vicariously from his son's classical education (see cat. 19 and 20).

29 Horace, *Odes*, III, xxix, 32–33. I am grateful to Bijan Omrani for his translation.

30 'Journey from Whitchurch, August 7-8, 1731', in Richardson 1776, pp. 309–21, at p. 320.

31 Letter to Ralph Palmer, 12 April 1736, British Library MS 71245 D. Palmer was a barrister and a friend of Sir Hans Sloane.

32 Letter to Ralph Palmer, 12 April 1736.

33 Ashmolean Museum, Oxford, WA.1894.64.

34 Richardson 1715, pp. 9–10.

35 'Journey from Whitchurch, August 7-8, 1731', in Richardson 1776, pp. 309–21, at p. 321.

36 Vertue 1746, title page. See also Alexander 1997.

37 See Gibson-Wood 2000, p. 123.

38 See Geest 2005, pp. 134–35. The provenance of the Faithorne pastel is discussed in Martin 1961, p. 10. One of Richardson's portrait drawings of Milton is inscribed *Milton from Cooper* (in Cornell University Library, Ithaca, Hibbert-Ware album, no. 4600; illustrated in Eddy 1988, no. 2). The reference to Vertue's ownership of the bust of Milton appears in the 1772 sale catalogue (see note 1), lot 55 of day one: "Sixteen heads of Milton after a bust, in the possession of the late Mr. Vertue"; in 'The art world in Britain 1660 to 1735', accessed 10 January 2015.

39 Raatschen 1996, pp. 813–16, at p. 813.

40 *A catalogue of the genuine and entire collection of Italian and other drawings, prints, models and casts of the late eminent Mr Jonathan Richardson, painter* (London 1747); in 'The art world in Britain 1660 to 1735,' at http://artworld.york.ac.uk; accessed 1 July 2014. The bust is lot 24 of day one.

41 Lugt 2183. This particular print was later owned by the collector Clayton Mordaunt Cracherode, who also acquired around fourteen drawings by Richardson himself. For Richardson's collection, see Gibson-Wood 2003, pp. 157–59.

42 Richardson 1715, p. 140.

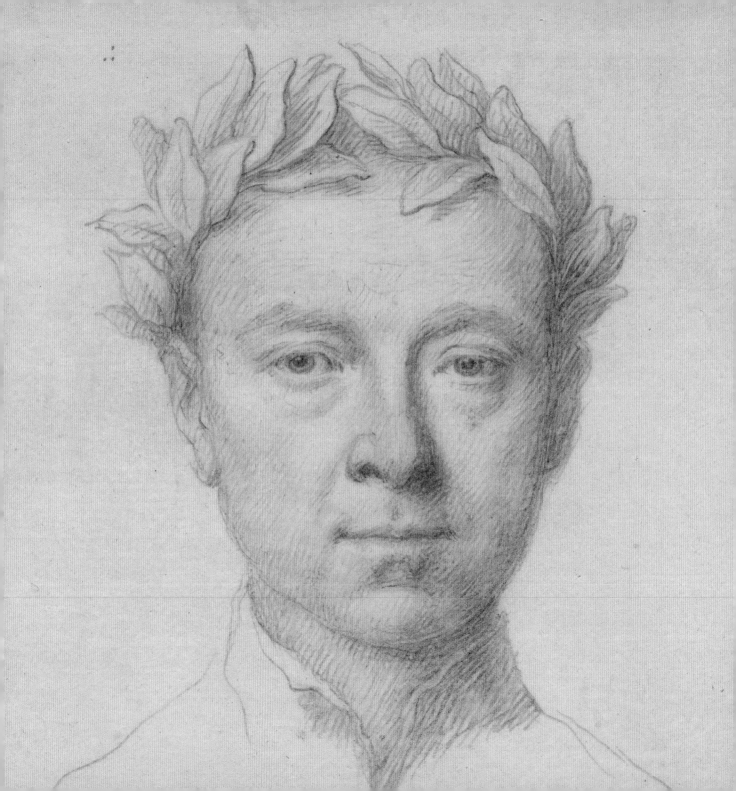

Catalogue

1

Self-portrait, 1728

Black and white chalk on blue paper, 480 × 307 mm
Inscribed on the recto, lower centre, in pen and ink: *Richardson Senr by himself*
and lower right in black chalk, in Richardson's hand: *4 May 1728*
The Courtauld Gallery, London, D.1952.RW.1552

PROVENANCE Richardson Senior (Lugt 2184, recto); presumably Richardson Junior; presumably
his sale, 1772; Sir Robert Witt (bought Sotheby's, 17–18 April 1923, lot 128; Lugt 2228b on verso);
by whom bequeathed to the Courtauld Institute of Art, 1952

This is among the very first self-portrait drawings Richardson created, and it marks the point at which he was embarking on what would become a sustained project of self-examination. It reveals that the essentials of the chalk-on-paper portrait drawings were in place from the outset. There is no background of any kind nor any attribute or prop, and the clothes are only lightly indicated: this is as pared-down as portraiture gets. Over the following years Richardson modified the style of his chalk portraits; the earliest share an emphatic boldness and strong linear contour, which is particularly evident in this example.[1]

Richardson usually chose to use blue paper rather than white for his large-scale self-portrait drawings. Blue paper, which in the eighteenth century was used for wrapping goods such as sugar, was cheap and readily available – and offered a resilient drawing surface. It also provided a mid-tone which allowed for more subtle tonal effects than white paper. For Richardson the drawings collector, though, blue paper was not only a practical and aesthetic choice – it also had art historical resonance, being particularly associated with Venetian artists such as Tintoretto and Veronese, who were well represented in his collection.

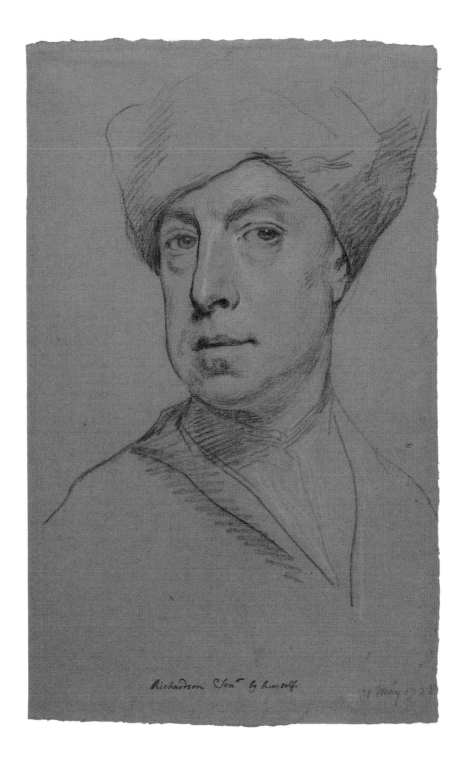

Richardson Sen.ᵗ by himself 9 May 1728

2

Self-portrait, 1728

Black and white chalk on blue paper, 442 × 295 mm
Inscribed on the recto, lower right, in pen and ink: *24 June 1728* and below by Horace Walpole:
His son has written on the back Ubi se à vulgo x scenâ, in secreta remôrat.
The British Museum, London, 1902,0822.44

PROVENANCE Richardson Senior (Lugt 2184, recto); presumably Richardson Junior;
presumably his sale, 1772; Horace Walpole, 4th Earl of Orford; Henry Graves & Co.; E. Parsons
& Sons; acquired by the British Museum, 1902

A remarkably direct and penetrating portrait, this work establishes the mood of private reflection and self-searching that is particularly characteristic of the chalk drawings. In comparison with cat. 1, drawn a month previously, there is a greater focus on the modelling of the face; except where it frames the head, the cap is only indicated summarily, the shirt hardly at all.

The words at the bottom of the sheet below the date were written by Horace Walpole while the drawing was in his ownership, and they record an inscription on the back which, according to Walpole, is in the hand of Richardson the Younger.[2] The full line, "*Quin ubi se a vulgo et scenâ in secreta remôrant*", is a quotation from the *Satires* of the ancient Roman poet Horace. Meaning 'When they keep themselves in secret from the mob and public eye', it presumably refers to the seclusion within which Richardson made the drawing, away from the demands of a busy portrait practice.[3]

As well as adding inscriptions to a number of self-portrait drawings, Richardson Junior freely embellished his father's poems with quotations from classical sources – mostly Horace, who was immensely popular in eighteenth-century England – when he edited a selection for publication as *Morning Thoughts*.

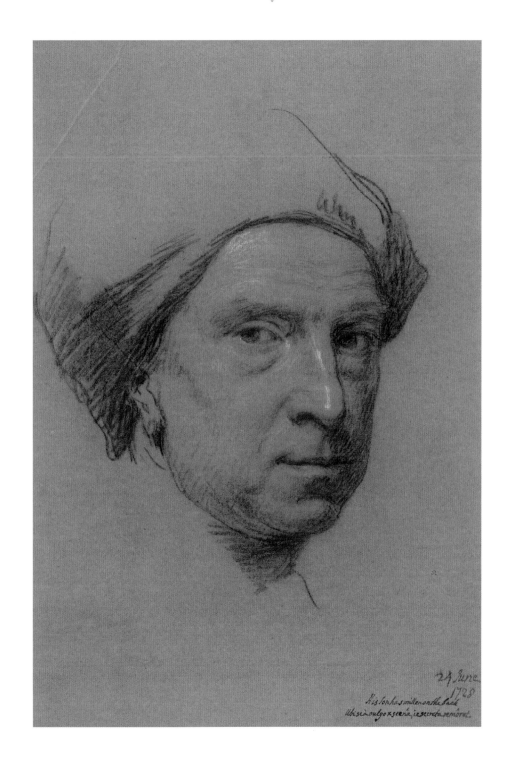

24 June
1728
His lot has millions on the back
Ubi sea vulgo x scena, in secreta semorat.

3

Self-portrait, c. 1728–33

Red chalk over grey wash on white paper, 373 × 283 mm
The British Museum, London, 1870,1008.2384

PROVENANCE Richardson Senior; presumably Richardson Junior; presumably his sale,
1772; Horace Walpole, 4th Earl of Orford (?); Henry Graves & Co.; purchased by the British
Museum from Colnaghi, 1870

Over the course of his life Richardson assembled
one of the era's finest collections of Old Master
drawings, which at his death numbered close to
5000 sheets. He lavished attention on his drawings,
researching them, frequently referring to them in his
books and making mounts with wash-line borders
designed to tone with individual works. Certain
unusual factors in this self-portrait suggest that
Richardson also found inspiration in his collection:
it appears to be based on a portrait head by Gian
Lorenzo Bernini, now in the British Museum, that
he owned (fig. 6); his collector's mark can be seen
at bottom right.[4] While the majority of Richardson's
chalk self-portraits are predominantly in black chalk
on blue paper, here – to dramatic effect – he has used
red chalk on paper to which he has applied a grey
wash, seemingly with the intention of approximating
the tonalities of the Bernini drawing. Other features
of Richardson's drawing, all unusual for him, support
this interpretation – the parted lips, the turn and
slightly forward thrust of the head, the longer than
usual hair and the subtly oblique direction of the
eyes all echo characteristics of the seventeenth-
century drawing. In addition, Richardson's portrait
is on the same scale as Bernini's.

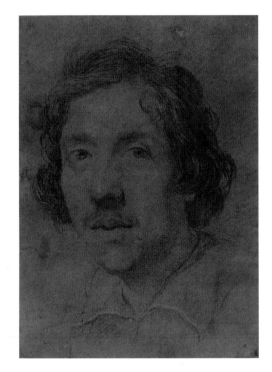

FIG. 6
Gian Lorenzo Bernini
*Portrait of a young man (possibly
a self-portrait)*, 1620s
Red chalk, heightened with white,
on buff paper, 365 x 264 mm
The British Museum, London,
1897,0410.10

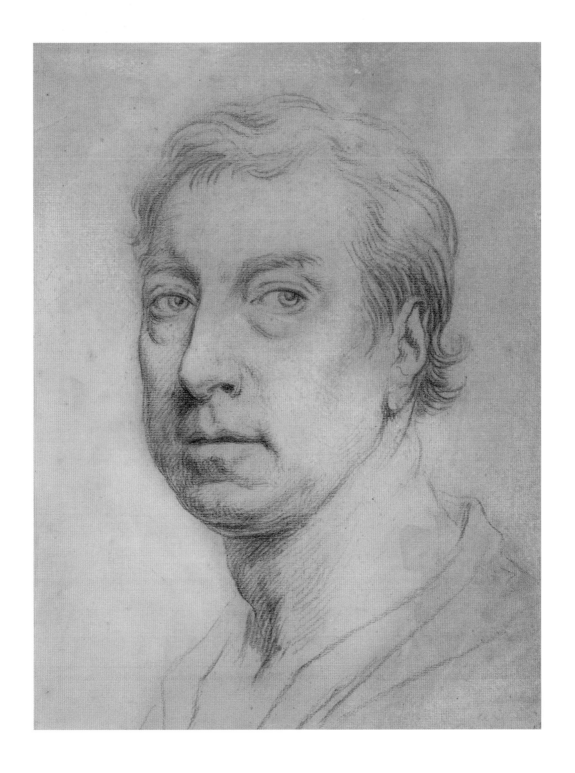

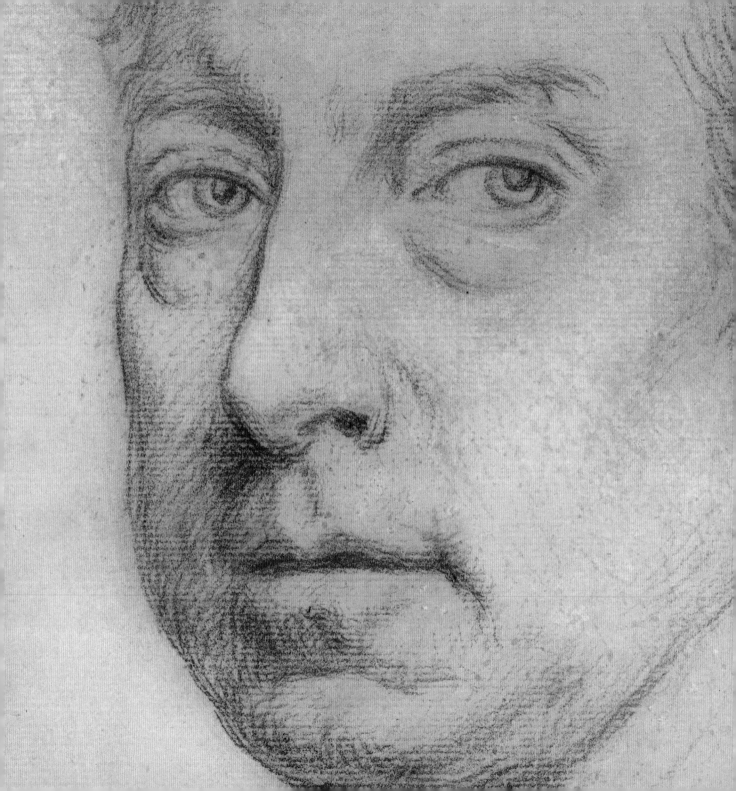

Perhaps most significantly of all, Richardson believed his drawing to be a self-portrait by Bernini rather than a generic head study, and wrote on the back of the mount he made for it: *Giov: Lorenzo Bernini | Scholar of Pietro | was born in Florence, | Painter Sculptor | and Architect, lived. | Rome. His own Head*. Whether or not the drawing is, in fact, a self-portrait, what is important is that Richardson thought it was – and, as a self-portraitist himself, Bernini's engaging, searching drawing evidently had a distinct resonance for him. Richardson also owned a cast of Bernini's bust of Charles I, from which he made numerous drawings.

By basing a self-portrait drawing on this exemplar, Richardson was engaging with Bernini in a more subtle and intimate way than if he had merely been making a copy. It reveals that Richardson was identifying with, or measuring himself against, Bernini, in much the same way as when he apparently drew himself as Rembrandt (cat. 11) – which would suggest that he was concerned to establish his own position in the art-historical canon.

Unusually, this drawing is not inscribed with a date – which, again, suggests that it was made for a different purpose from the other self-portraits. The date range proposed here, *c.* 1728–33, would situate it within the main sequence of chalk self-portrait drawings executed with relatively bold lines.

4

Self-portrait, 1730

Graphite on vellum, 156 × 127 mm
Inscribed lower right, in graphite: *5 Dec. 1730*
National Portrait Gallery, London, 1831

PROVENANCE Richardson Senior; presumably Richardson Junior; presumably his sale, 1772;
Richard Budgett; by whom given to the National Portrait Gallery, 1918

Richardson's earliest known graphite-on-vellum self-portraits date from 1730. These are dramatically different from the chalk drawings in scale, the small leaves of fine vellum contrasting with the large sheets of cheap blue paper. In some respects the graphite-on-vellum drawings have a distinct character of their own; while the chalk drawings tend to be introspective and self-searching, some (though not all) of the small vellum drawings present a more public face. In addition, graphite lends itself to a more precise and controlled drawing style than chalk. Both qualities are evident in this little self-portrait in which he has depicted himself wearing formal dress. Some of these graphite-on-vellum drawings copy existing portrait paintings, and it is possible that this particular work is loosely based on a self-portrait in oils he painted in 1728 (Polesden Lacey, National Trust), in which he represents himself with a similar tilt of the head, although in the oil he wears a hat.[5]

Like the chalk-on-paper drawings, those he drew on vellum are roughly uniform in size. Richardson perhaps pasted the majority of them into albums, which is how he housed and organised his large collection of Old Master drawings. Having begun his project of self-portraiture by drawing in chalks, it seems likely that he chose to begin this other sequence of graphite-on-vellum drawings to be consistent with the drawings of friends, acquaintances and historical figures that he made in large numbers, the great majority of which are drawn in that medium.

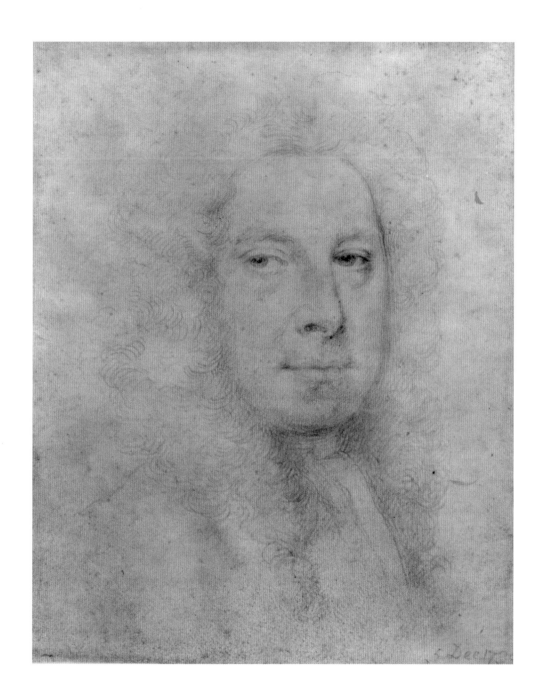

5

Self-portrait as a poet, c. 1732

Graphite on vellum, 168 × 130 mm
Inscribed on a slip of paper cut from the mount, in brown ink, by Jonathan Richardson the
Younger: *My Dear Late Father* and in an old hand: *Mr Richar[dson]*
The British Museum, London, Gg,1.510

PROVENANCE Richardson Senior; Richardson Junior (Lugt 2170, recto); presumably his sale, 1772;
Clayton Mordaunt Cracherode, by whom bequeathed to the British Museum, 1799

Richardson's playful depiction of himself as a celebrated poet, crowned with bays, is a close copy of another drawing, now in Cornell University Library. Dated 12 April 1732, the original has the following poem inscribed on the back:

> Yes Pope, yes Milton I am Bayes'd you see.
> But Why – go ask my Oracle, not Me:
> Shee, not Severe is Beautyfull, & Wise,
> Shee Thus Commanded me, & Thus it is.
> May You enjoy your plentitude of Fame!
> While Shee with Smiles embellishes my Name
> I ask not Your Applause, nor Censure Fear,
> I am Pope, Milton, Virgil, Homer Here.

The "Beautyfull, & Wise" "Shee" of this poem is Catherine Knapp, with whom in the early 1730s Richardson (by then a widower) enjoyed a close friendship which was founded on a shared love of poetry.[6] Richardson had met Mrs Knapp at Shardeloes in Buckinghamshire, the grand Elizabethan home of a mutual friend, Isabella Drake, with whom he frequently stayed. Catherine, born in 1691, was actually unmarried; the respectful title 'Mrs' was conferred because of her age and social position. Jonathan Junior, in his editorial notes to *Morning Thoughts*, described Mrs Knapp as "a lady of family and fortune, and fine qualifications, Mrs Drake's friend and companion, and for whom my father had himself an extraordinary esteem and regard", and characterised her relationship with Richardson as "a poetical friendship".[7] Richardson drew a number of particularly sensitive and lively portraits on vellum of Mrs Knapp (see fig. 5), and the line "Shee Thus Commanded me" in the poem quoted suggests that, in return, she had asked him for a self-portrait. It is probable that he gave the drawing inscribed with a poem to her; the present sheet is a faithful copy that took its place in his own collection.

Richardson had no illusions about the quality of his own poetry, and indeed he wrote a self-deprecating poem in which he compared the "ven'son" of Alexander Pope's poetry to the "mutton" of his own.[8] In the above verse, he explains that it is Mrs Knapp's favourable attention to his poetry that richly compensates him for his lack of fame, making him feel as proud as if he were all of the poets listed in the final line rolled into one.

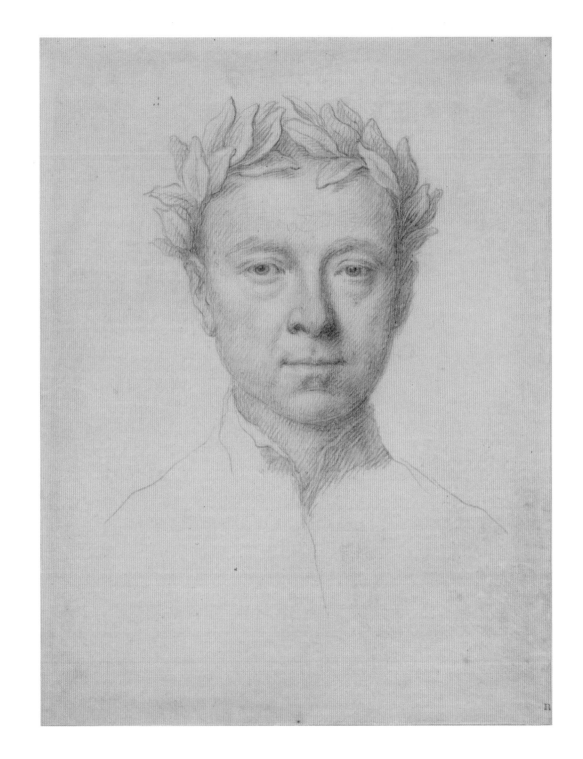

6

Self-portrait, 1732

Graphite on vellum, 181 × 140 mm
Inscribed on the recto, lower right, in pen and ink: *14 Sep.1732* and signed on the verso,
lower left, in pen and ink: *I. R. Senr.1732*
The Fitzwilliam Museum, Cambridge, 1659

PROVENANCE Richardson Senior (Lugt 2184, verso); Richardson Junior (Lugt 2170, recto);
presumably his sale, 1772; John Barnard (Lugt 1419, verso); Alfred A. de Pass (Lugt 108a, verso);
by whom given to the Fitzwilliam Museum, 1933

This drawing is exceptional not only for the statement it makes about self-presentation – the artist appears as a model of assured elegance – but also for the exceptionally high quality of its draughtsmanship. Richardson has used fine strokes of graphite to model the face, applying light pressure to build up subtle detail with faint, unemphatic hatching, while indicating the fabric of his jacket with a freer, more rhythmic line.

In his choice of materials Richardson seems to have been echoing a particular sort of drawing that flourished in the last quarter of the seventeenth century, the 'plumbago' portrait, which offered an elegantly monochrome alternative to the portrait miniature. Plumbagos were drawn with graphite (the term 'plumbago', meaning black lead, is a misnomer) on small sheets of vellum. Not only more durable than paper, vellum offered a smoother drawing surface without the ridges intrinsic to laid paper (wove paper, which had a uniform surface, did not become available until the 1780s). Hard, finely pointed graphite was ideal for depicting intricate details of costume, and its natural lustre lent a subtle liveliness to plumbago portraits. The virtuoso use of graphite seen in this portrait derives from the precedent of the plumbago – before its arrival, graphite had been considered only to be suitable for training and for preparatory work.

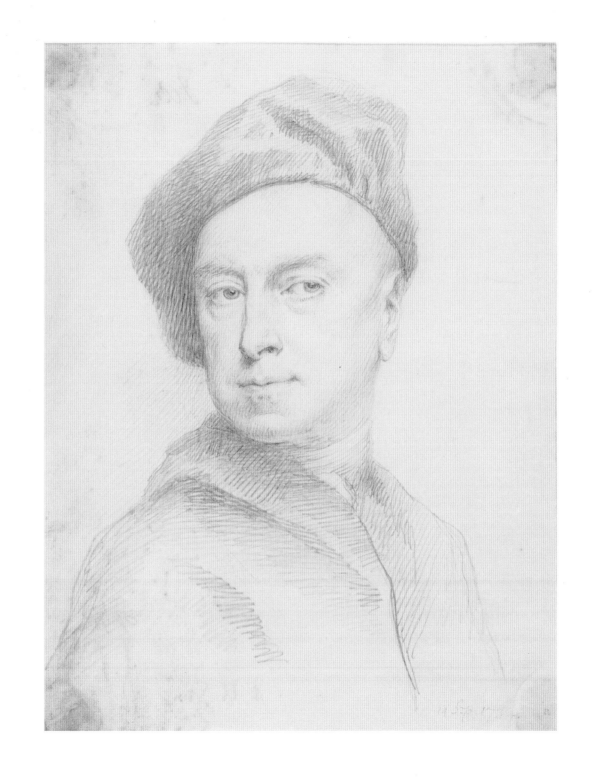

7

Self-portrait in profile, 1732

Black, red and white chalk on blue paper, 378 × 271 mm
Inscribed on the recto, on a slip of blue paper pasted on the lower left, in red chalk: *5 Oct 1732*
The Courtauld Gallery, London, D.1952.RW.3932

PROVENANCE Richardson Senior (Lugt 2184, recto); presumably Richardson Junior; presumably his sale, 1772; Sir Robert Witt (bought Sotheby's, 3 December 1947, lot 91; Lugt 2228b, verso); by whom bequeathed to the Courtauld Institute of Art, 1952

Richardson made a number of portraits of himself in profile at around this time, both in chalks and in graphite, seemingly becoming interested in exploring this aspect of his appearance. In order to make a drawing of this kind he would have carefully positioned two mirrors to reflect his profile.

While the earlier chalk drawings are in black chalk with highlights added in white, for this self-portrait Richardson has introduced red to model the cheeks, nose and chin, producing a less austere, more naturalistic appearance – an effect of the colouristic technique that was known in France as *trois crayons* (three chalks). The red line used to define the contour of the face is drawn over the top of a fainter black line, giving a subtly softer impression than black alone. Chalk is a particularly versatile medium because it is soft and responsive enough to work rapidly on a large scale, and it can also be sharpened to a point for contour lines, such as those used to define the head and face.

The profile portrait, such as that found on coins and medals, is associated with classical antiquity, the severely pared-down, idealised representation being thought to convey nobility and authority. During the period at which Richardson made this self-portrait, coins and medals were immensely popular with collectors such as his friend Dr Richard Mead, who had a celebrated collection. In 1726 the essayist Joseph Addison published a *Dialogue upon the Usefulness of Ancient Medals, especially in relation to the Latin and Greek Poets*, prefaced with a poem by Pope, 'Verses occasion'd by Mr Addison's treatise of medals'.[9] One of the interlocutors in Addison's dialogue remarks that "A cabinet of Medals is a collection of pictures in miniature", an observation that underlines the contemporary perception of their link with portraiture.[10]

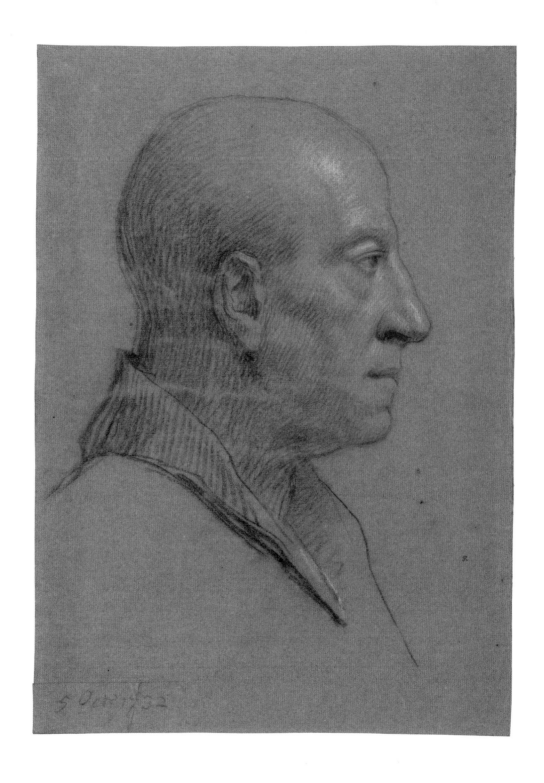

5 Octr/32

8

Self-portrait in profile, 1732

Graphite on vellum, 139 × 119 mm
Inscribed on recto, lower right, in pencil: *7 Oct 1732*
The Courtauld Gallery, London, D.1952.RW.1663

PROVENANCE Richardson Senior (Lugt 2184, verso), Richardson Junior (Lugt 2170, recto);
presumably his sale, 1772; John Barnard (Lugt 1419, verso); Graves sale, Sotheby's,
25–26 June 1923, lot 40, bought Sir Robert Witt (Lugt 2228b, verso); by whom bequeathed
to the Courtauld Institute of Art, 1952

The careful dating of Richardson's drawings allows us to compare this one with a very similar self-portrait in chalks made just two days before, which also shows him bareheaded and in profile (cat. 7). Although Richardson used graphite for a wider range of portrait types than he did chalk, there is a large area of overlap and he often employed different media to make very similar portraits, as a comparison between these two drawings demonstrates.

Richardson has exploited the delicacy of graphite to create subtle modelling in this sensitive self-portrait. Rods of graphite (an allotrope of carbon) had, since the late seventeenth century, been inserted into pine, deal or cedar-wood casings and sold as pencils, one such of which is presumably what Richardson was using here. It was not until the late eighteenth century that Nicolas-Jacques Conté's experiments with mixing finely ground graphite powder with clay and water and baking it in long, narrow moulds eventually led to the range of hard and soft graphite pencils available today. The graphite that was available in Richardson's time was a hard, less responsive material that left a delicate, silvery line on the drawing surface. The smooth, slightly polished surface of vellum emphasised graphite's natural sheen more than the matt texture of paper.

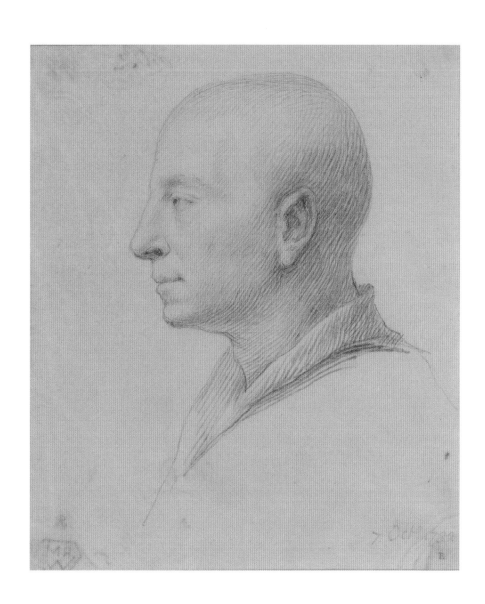

9

Self-portrait in profile, 1734

Graphite on vellum, 123 × 113 mm
Inscribed on the verso, in graphite: *17 Dec: 1734* and in brown ink in another hand: *I* [struck out?] *R Senr.*
The British Museum, London, Gg,1.479

PROVENANCE Richardson Senior; presumably Richardson Junior; presumably his sale, 1772;
Clayton Mordaunt Cracherode, by whom bequeathed to the British Museum, 1799

This elegant *jeu d'esprit* shows Richardson elaborating on the idea of the profile portrait, taking it to its conclusion by presenting himself *all'antica*, as though represented on a coin or medal (see cat. 7). Probably referring back to cat. 8, to which it bears a close resemblance, he has added a circular border to this drawing, framing his portrait in a roundel, and has cut through the neck as though it were a low-relief portrait. A comparison with the 1732 drawing reveals that, in this work, he has subtly idealised his features by slightly strengthening the chin and set of the mouth, and has given the eyes and other features more definition.

Comparing this drawing with his earlier profile portraits illuminates the process by which Richardson arrived at his more playful, self-dramatising works. In exploring the possibilities of different themes he evidently referred back to previous drawings when developing an idea.

Richardson's self-portrait drawings were clearly valued later in the eighteenth century, as many of them were acquired by distinguished collectors. Significant groups, now in the British Museum, were purchased by Horace Walpole, an important early historian of English art, who bought a large number at Jonathan Junior's sale in 1772, and – as is the case with the present drawing – by Clayton Mordaunt Cracherode, a highly discriminating collector of books, prints and drawings.

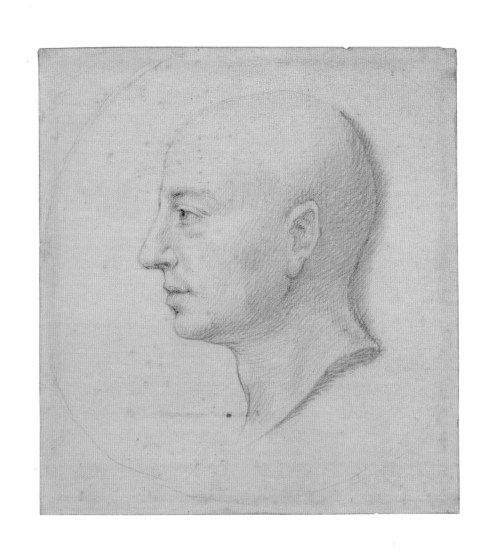

10

Self-portrait at the age of twenty-five, 1735

Graphite on vellum, 135 × 104 mm
Inscribed on the verso, in graphite, in the artist's hand: *Painted abt. May 1692 | 31 Jan 1734/5*
and in brown ink by Jonathan Richardson the Younger: *Mr. Richardson Senr.*
The British Museum, London, 1872,1012.3382

PROVENANCE Richardson Senior; presumably Richardson Junior; presumably his sale, 1772;
Edward Daniell, from whom purchased for the British Museum, 1872

Richardson's portrait drawings, particularly those in graphite on vellum, are a form of visual autobiography, documenting not only his contemporary appearance but also that of his younger self. An inscription on the back of this particular drawing records that it is a copy of an oil he had painted around 1692 (now untraced).[11] Its technique differs from that of most of the other graphite-on-vellum drawings as there is more uniform overall shading and the cravat, coat and wig are drawn with greater detail than usual, factors consistent with its status as a copy of an existing work.

Richardson might well have wanted to commemorate his appearance in 1692, because this was a pivotal year in his life. It saw the earliest stages of his professional career; his master, the portraitist John Riley, had died prematurely in 1691 while Richardson was still apprenticed to him; and, on a personal level, Richardson's marriage – to Riley's niece Elizabeth Bray – followed in 1693.

Drawing his own portrait as a younger man evidently prompted Richardson to reflect on his progression through life, because the following day, 1 February 1735, he wrote a poem about the passing of time entitled 'Enjoy the Present'. Following the heartfelt remark "Life now is so much shorter than it was", he weighs the year's turn from winter to spring against the inexorable diminishment of his life ahead:

But now the vernal bloom, the gaudy May
Is a month nearer than on New-year's-day,
Granted. But 'tis as evidently true,
The hour of death is a month nearer too.[12]

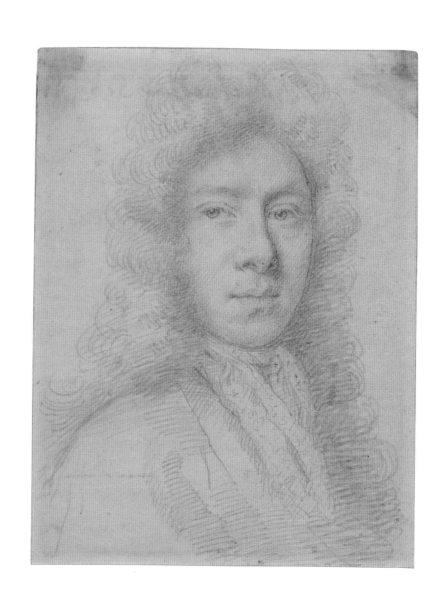

11

Self-portrait at the age of thirty, 1735

Graphite on vellum, 146 × 116 mm
Inscribed on verso, lower right, in pencil: *the Orig:done abt May 12 1697* and below, in pencil: *3 Mar 1734/5*
and upper centre, in pencil, in Jonathan Richardson Junior's hand: *My Father* and lower centre, in pen
and ink in an 18th- or 19th-century hand (note on object file: "J Richardson Jnr's?"): *J R Senr*
The Courtauld Gallery, London, D.1952.RW.1660

PROVENANCE Richardson Senior (Lugt 2184, verso bottom right); Richardson Junior (Lugt 2170, recto
bottom right, almost completely worn away); presumably his sale, 1772; John Barnard (Lugt 1419, verso);
Graves sale, Sotheby's, 25–26 June 1923, lot 40?, bought Sir Robert Witt (Lugt 2228b, verso); by whom
bequeathed to the Courtauld Institute of Art, 1952

An inscription on this drawing records that it
was copied from an existing portrait (untraced),
presumably an oil painting, made in 1697, when
Richardson was thirty. This drawing was made at
around the same time as cat. 10, suggesting that he
was making a concerted effort at the time to assemble
autobiographical images representing himself at
different ages. This preoccupation with narrating the
story of his own past had surfaced previously, as a
poem of 1729, 'My Different Times of Life', illustrates:

> My early steps in life, on barren ground,
> Inhospitable and severe were found,
> The next, laborious, but more prosp'rous were,
> Not unattended yet with ceaseless care;[13]

The self-portraits as a younger man and a poem such
as this one can be regarded as belonging to the same
project – of reviewing aspects of his own past from
the vantage point of age.

The uncharacteristic headgear sported in this
portrait has been compellingly interpreted as
signalling an homage to Rembrandt, whose work
Richardson valued highly and whose drawings and
etchings he collected avidly.[14] A comparison between

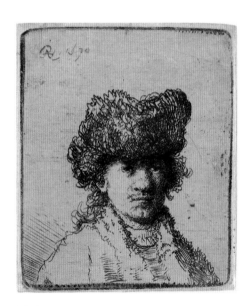

FIG. 7
Rembrandt van Rijn
Self-portrait in a fur cap, 1630
Etching, 62 x 51 mm (platemark)
Ashmolean Museum, Oxford,
WA 1855.402

this drawing and an etching of 1630, *Self-portrait in a
fur cap* (fig. 7), makes a telling point, especially in the
context of Richardson's self-portrait based on another
great artist of the seventeenth century, Bernini (cat. 3).

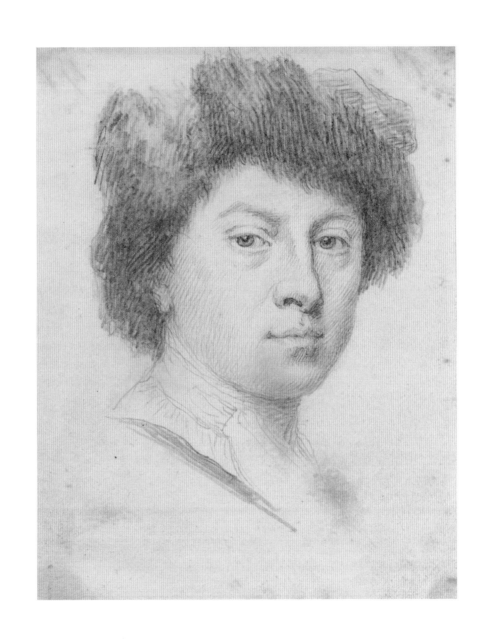

12

Self-portrait, 1735

Black and white chalk on blue paper, 237 × 267 mm
Inscribed upper centre, in pen and ink, in a later hand: *Mr. Jonathan Richardson engraver. (an original)*
and lower left, in pencil, in a later hand: *by himself 3/6* and lower right, in chalk, in the artist's hand: *Oct 1735*
National Portrait Gallery, London, 3779

PROVENANCE Richardson Senior (Lugt 2184, recto); presumably Richardson Junior; presumably his sale,
1772; Dr William Fleming Collection; transferred to National Portrait Gallery, 1950

This is among the most touching self-portraits Richardson made. Representing himself with unflinching honesty as a vulnerable elderly man, bareheaded without his cap, Richardson appears to confront the fact of his own ageing – a theme to which he often returned in his poetry. In a poem he composed at around the time he drew this portrait, 'Unconcerned for Outward Beauty', he writes:

> Decaying face, or face decay'd,
> Thou shalt ere long in dust be laid,
> But then thou wilt no more be mine.
>
> Ye features, never much approv'd
> By me, nor made to be belov'd,
> Which now I, not regretting, view,
> No matter what becomes of you.[15]

The conceit of the poem is that Richardson is looking in a mirror and addressing his own appearance, just as he would have done to make a self-portrait – and subjecting himself to the same scrutiny.

The chalk portrait drawings Richardson made around the time he drew this portrait, 1735, differ from those he produced at the outset of the project. By 1735 he typically drew in a softer manner, abandoning the bold contours that characterise the earlier drawings; works such as this one have what has been described as a "reticent, almost tentative quality".[16] This development in Richardson's manner of drawing suggests that, over time, the self-portraits began to have a subtly different significance for him. The psychologically penetrating stare of the earlier works softens into a more sympathetic gaze, apparently signalling an acceptance of his own ageing – a state of mind perhaps brought about by the investigative process of self-portraiture itself.

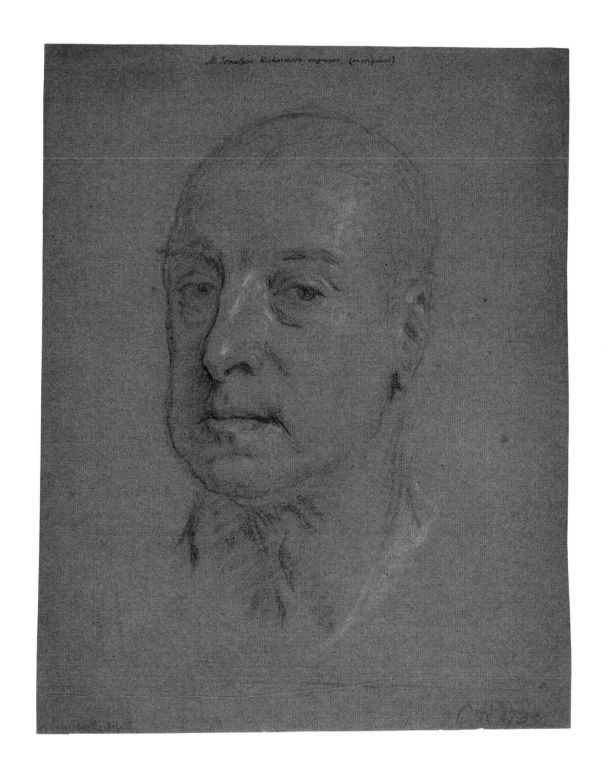

13

Self-portrait, 1735

Graphite on vellum, 100 × 78 mm
Inscribed on verso, lower right, in graphite: *21 Nov: 1735*
The Courtauld Gallery, London, D.1952.RW.1662

PROVENANCE Richardson Senior (Lugt 2184, verso); Richardson Junior (Lugt 2170, recto); presumably his sale, 1772; John Barnard (Lugt 1419, verso); Graves sale, Sotheby's, 25–26 June 1923, lot 40, bought Sir Robert Witt (Lugt 2228b, verso); by whom bequeathed to the Courtauld Institute of Art, 1952

Unusually sketchy in comparison with Richardson's other graphite-on-vellum drawings, this self-portrait has an air of spontaneity, strongly suggesting that it was drawn directly from the life. He has used an unsharpened pencil, which produces a softer, blunter line than, for example, the sharp point which gives the portrait he made in September 1732 such a sophisticated quality (cat. 6). Although in a different medium, this little drawing is comparable with cat. 12 in its hesitancy, lack of polish and touching unguardness. The two drawings were done within a few weeks of each other.

As a passionate collector, Richardson championed drawings and particularly appreciated their sketchy, unfinished quality and their capacity to communicate ideas. In his *Essay on the Theory of Painting* he remarks that "There is a Spirit, and Fire, a Freedom, and Delicacy in the Drawings of Guilio Romano, Polydoro, Parmeggiano, Battista Franco, &c. which are not to be seen in their Paintings".[17] He expressed a similar idea about the value of the sketch in a poem of the same period, dated 29 September 1735, 'My Manner in Writing'. Here he compares his composition of an abundance of verses, which reflect what he calls his "velocity of sense", to an artist making quick drawings rather than laborious oil paintings, and concludes:

But greatest masters often fetch
More glory from a rapid sketch,
Than from the most completing toil,
And charge of colours, cloth, and oil.[18]

The obtrusive collector's mark stamped at the lower left of this sheet has not been identified, and for the time being its significance for the drawing's provenance remains a mystery.

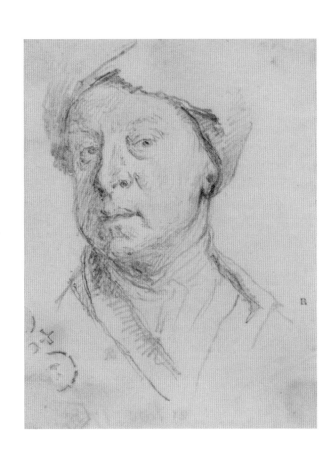

14

Self-portrait, 1736

Pen and ink over preparatory graphite on pale buff paper, 162 × 114 mm
Inscribed lower right, in pencil, in the artist's own hand, a cipher, *9 P 7 G.* and below, in
pen and ink: *15 Jan 1735/6* and lower centre, in pen and ink, in an old hand: *Richardson.*
drawn by himself
National Portrait Gallery, London, 3023

PROVENANCE Richardson Senior (Lugt 2184, recto); presumably Richardson Junior;
presumably his sale, 1772; Marion Harry Spielmann; by whom presented to the National
Portrait Gallery, 1939

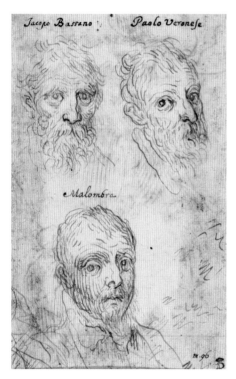

The unpolished directness and disconcertingly
modern air of this drawing makes it one of the
most arresting in Richardson's oeuvre. Although he
sometimes used pen and ink in his working practice,
this was mostly for schematic preparatory sketches
for drawings on vellum. The present drawing is,
therefore, unusual in that, although unfinished, it
appears to have been conceived as an independent
portrait – and is a rare example of Richardson's overall
use of vigorous pen-and-ink hatching to express the
contours of the face.

It has been convincingly suggested that in his
unusual choice of materials and uncharacteristic
handling here Richardson was emulating a drawing
by the sixteenth-century Venetian artist Palma il
Giovane that he knew from the collection of Lord
Somers, a close neighbour in London (fig. 8).[19] As
an acknowledged expert on Old Master drawings,
Richardson had been consulted by Lord Somers
and asked to catalogue and arrange his collection,
which he did between about 1713 and 1716.[20] We
can be certain that he knew this particular drawing
by Palma, a sheet of three portrait heads identified
by the inscriptions as the artists Jacopo Bassano,
Paolo Veronese and Pietro Malombra, because there

Richardson. drawn by himself 15 Jan 173⁵⁄₆

is evidence that he re-mounted it.[21] In his use of unusually long strokes of the pen, Richardson seems to have been emulating Palma's method of modelling the face; his technique is particularly close to that used for the head at the bottom of the sheet.

Richardson was also invited to work on the Devonshire collection of Old Master drawings, during which time he made a close pen-and-ink copy of a small sheet of three head studies that he found there; this drawing, formerly thought to be by Titian, is now given to Palma Giovane.[22] In making this copy, presumably for his own collection, Richardson meticulously reproduced individual lines and calligraphic flourishes of the pen.

15
Self-portrait, 1736

Graphite on vellum, 135 × 101 mm
Inscribed on the verso by the artist *31 Aug. 1736* and by the Rev. C.M. Cracherode: *J. Richardson senr.*
The British Museum, London, Gg,1.508

PROVENANCE Richardson Senior; Richardson Junior (Lugt 2170, recto); presumably his sale, 1772;
Clayton Mordaunt Cracherode, by whom bequeathed to the British Museum, 1799

This may be among the last graphite-on-vellum
self-portrait drawings Richardson made. After 1736
he made few self-portraits in any drawing medium,
although he continued to draw other sitters into
the 1740s and made at least two of his self-portrait
etchings in 1738. As with cat. 13, the bold contours
and summary, choppy lines of this drawing suggest
that it was drawn from the life – it was evidently
not conceived as the same sort of drawing as the
polished cat. 6.

1736 was also a significant year for Richardson as
a poet, because the final poem included in *Morning
Thoughts* – tellingly entitled 'Self-Examination' –
is dated 9 November 1736. Although the poems
published in this volume are, as mentioned above,
selected from "a much larger number intended
for publication", the fact that they are arranged in
chronological order suggests that they cover the
principal period of Richardson's poetic activity.[23]
That Richardson's productivity both as a poet and as
a self-portraitist appears to have tailed off at this point
suggests that, for him, the two art forms were closely
linked – and also that this period of introspection had
largely run its course.

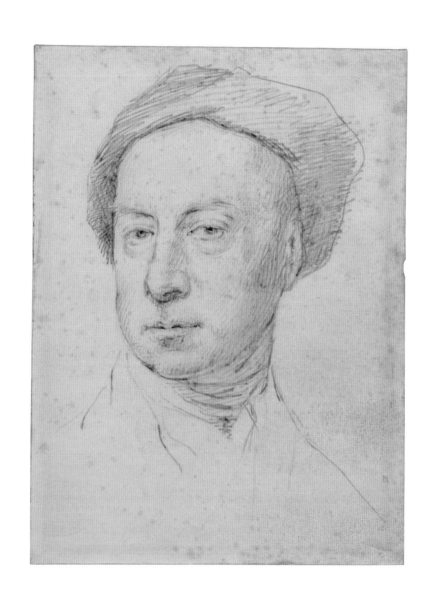

16

Self-portrait, 1738

Etching on paper, 208 × 132 mm (sheet size)
Lettered, lower centre: *Me, as you find my soul, neglect or Love | and show by Virtue Virtue you approve. |*
R. 1738. and inscribed underneath *J. Richardson the Painter*
The Courtauld Gallery, London, G.1990.WL.5419

PROVENANCE Richardson Senior; presumably Richardson Junior; presumably his sale, 1772; Sir Robert
Witt, by whom presented to the Courtauld Institute of Art, 1944; transferred from the Witt Library, 1990

Richardson was a prolific etcher. The sale catalogue of
Jonathan Junior's collection lists around 400 etchings
by his father, although this figure includes multiple
impressions taken from a much smaller number
of plates. The majority are self-portraits (of which
five are known), and portraits of his son, Alexander
Pope and John Milton. Richardson's subjects also
included landscapes and copies after Old Master
drawings. Unlike engraving and mezzotint, which
were technically demanding and required professional
training, etching was, essentially, as easy as drawing:
it required only a copper plate coated with wax, and
a needle with which to draw the design. Discussing
etching in his work *Two Discourses*, Richardson made
this comparison, remarking that "if it be Design'd
on the Plate 'tis a kind of Drawing", and, moreover,
one that is "purely, and properly Original".[24]

Given the large number of impressions he produced,
it is possible that Richardson's studio equipment
included a small proofing press, although it is more
likely that he took his plates to a print publisher, such
as his friend and neighbour in Great Queen Street,
Arthur Pond. In partnership with the etcher Charles
Knapton, in 1735–36 Pond published *Prints in Imitation
of Drawings*, which included etched copies of 21
drawings from Richardson's collection.

This self-portrait was used as the frontispiece
to the published edition of Richardson's poems,
Morning Thoughts, which was published in 1776, over
thirty years after his death. It is not known whether
this etching was chosen for the book by Richardson
himself or whether it was selected by his son, who
edited his father's poems for publication. However,
given that Richardson wrote a brief preface intended
for a published collection of his poems, it is highly
likely that he would also have chosen the image by
which he wanted to be represented – or even made
it especially for the purpose.[25] In which case, the
couplet he composed to accompany the image takes
on a special significance as an epigraph for the work
to follow. The first line, "Me, as you find my soul,
neglect or Love", is ambiguous, perhaps deliberately
so – by "Me" and "my soul" does he mean the
self-portrait image, or the self-representation that
follows in the poems? This apparent blurring of the
distinction between portrait and poetry is revealing,
suggesting that Richardson regarded these two forms
of expression as a continuum. The second line, the
exhortation to "show by Virtue Virtue you approve",
introduces a moral dimension – one that is extended
to include the reader. This self-portrait is particularly
significant as a pivotal point between the visual and
textual areas of his output, and as a statement of his
preoccupations with morality and selfhood.

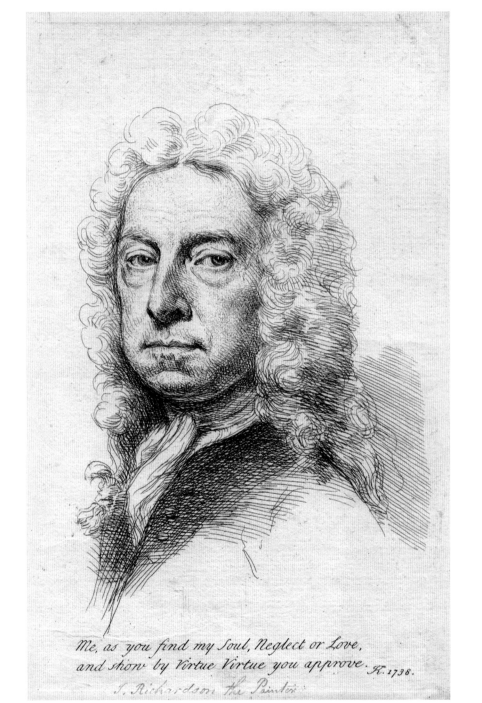

Me, as you find my Soul, Neglect or Love,
and show by Virtue Virtue you approve. Æ. 1736.

S. Richardson the Painter.

17

Self-portrait, c. 1738

Counterproof on paper, 195 × 137 mm
Lettered in reverse, lower centre: *Me, as you find my soul, neglect or Love | and show by Virtue*
Virtue you approve. | R. 1738.
David Solkin

PROVENANCE Richardson Senior; presumably Richardson Junior; presumably his sale, 1772;
Justin Skrebowski, from whom purchased *c.* 2000

The etching process allowed Richardson to explore new possibilities of making and modifying pictures: this print, for example, is a mirror image of cat. 16. It is a counterproof, which is made by taking an impression from a printing plate in the usual way, then placing a dampened sheet of paper on the surface of the fresh print and putting the two through the etching press so that the first sheet prints on to the second while its ink is still wet. While the image on a normal print is reversed from that scratched on to the etching plate, a counterproof appears the same way round. Professional etchers sometimes made counterproofs during the process of working on the plate, to enable them to see the progress of their work more easily. However, here Richardson has taken an impression from the finished plate, so his intention was, presumably, to make it the same orientation as his drawing on the plate and to check the likeness against the image he saw in the mirror.

In taking a counterproof Richardson perhaps also intended to modify the appearance of the self-portrait: while the etched lines of the print appear harsh and linear compared to graphite or chalk, the lines of the counterproof are fainter and more silvery, creating a softer and more subtle image. Counterproofs have long been prized by print collectors for their aesthetic qualities and for the insights they give into an artist's working process, which is perhaps another reason why Richardson created them from his own etchings.

On the evidence of other counterproofs ("reverses") mentioned in Jonathan Junior's 1772 sale catalogue – for example "Ten ditto [etchings] of Richardson, sen. and jun. proof, variations and reverses by ditto [J. Richardson, sen.]" – Richardson made numerous experiments with impressions from existing plates to achieve different effects.[26] On at least one occasion he drew a portrait over the top of a counterproof.[27] He also experimented with offsetting, a technique of reversing drawings by which a damp, blank sheet of paper is placed against a drawing and the two sheets put under pressure (run, for instance, through an etching press) so that excess chalk from the original is transferred to the second sheet.[28]

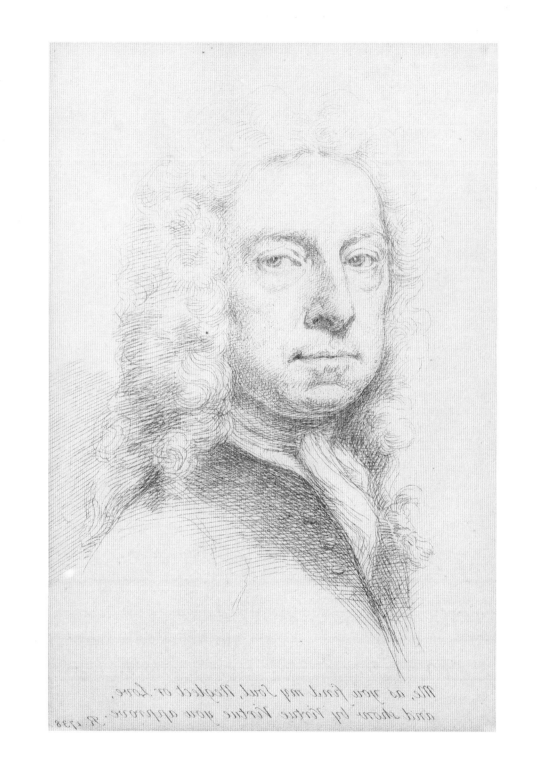

Me, as you find, my Soul, Neglect or Love,
and show, by Virtue, you approve. R 1738

18

Self-portrait, c. 1738

Red chalk on off-white paper, 505 × 339 mm
Inscribed on the recto, lower right, in red chalk: *20 Jan 173*[illegible digit]
The Courtauld Gallery, London, D.1952.RW.1590

PROVENANCE Richardson Senior (Lugt 2184, recto); presumably Richardson Junior; presumably
hissale, 1772; Mulready, 1864; Taylor, 1912; A. Chariatte, 1923; Puttick & Simpson, 4 May 1923,
purchased by Sir Robert Witt (Lugt 2228b, on back of paper mount); by whom bequeathed to
the Courtauld Institute of Art, 1952

This portrait is anomalous for two reasons: it is on a particularly large sheet of paper; and in it Richardson depicts himself dressed more formally than is usual in his chalk self-portraits. Rather than the habitual introspective or exploratory scrutiny of the chalk portraits, what he presents here is a public face – precisely the sort of demeanour that one might adopt "when one comes into Company, or into any Publick Assembly", that he considered particularly suitable for a portrait painting.[29]

This image is close to the self-portrait etching of 1738 (cat. 16), to which it is probably connected; as well as sharing a general pose and expression, they have certain small details in common such as the angle of the ribbon which ties the end of the wig at lower left. There are, however, sufficient differences, not least in scale, to make it unlikely that the etching was directly based on the drawing; moreover, the images are the same way round, whereas an etching copied from a drawing would appear in reverse. Given that the etched self-portrait appears to have been the image by which Richardson chose to be represented for posterity, and to which, therefore, he must have attached some importance, it is possible that the drawing was made as an enlarged and aggrandised version of it.

Its scale and air of being a considered statement suggest that this drawing might well have been conceived as an independent work of art to be framed and displayed. Richardson's choice of off-white paper rather than his usual cheaper blue also suggests that it was made for this purpose. It was certainly in a frame by the mid nineteenth century: a record of labels pasted on to the frame's old back-board has made it possible to establish a fuller provenance for this drawing than for the smaller works.[30]

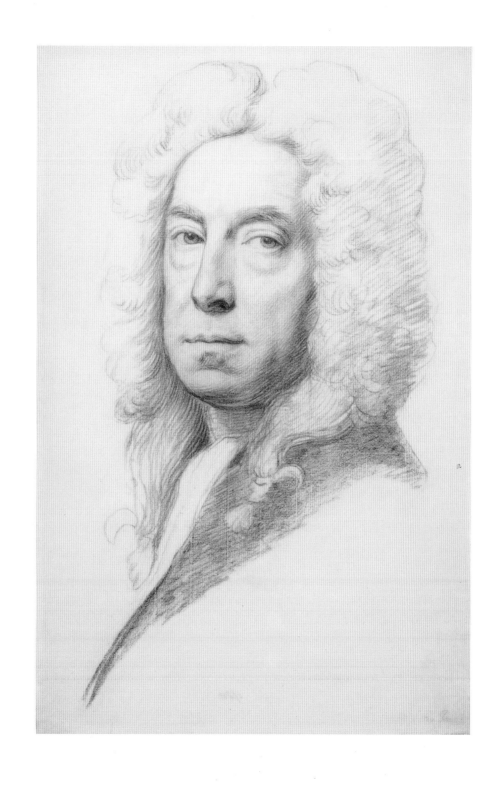

19
Portrait of Jonathan Richardson the Younger, 1733

Red, black and white chalk on blue paper, 286 × 239 mm
Inscribed on verso, lower right, in black chalk: *6 Aug 1733*
The Courtauld Gallery, London, D.1952.RW.1655

PROVENANCE Richardson Senior (Lugt 2184, recto); presumably Richardson Junior; presumably
his sale, 1772; Graves sale, Sotheby's, 25–26 June 1923, lot 43, bought Sir Robert Witt; by whom
bequeathed to the Courtauld Institute of Art, 1952

Richardson's eldest son, also called Jonathan, did not
marry and continued to live at home with his father,
for whom he often served as a model; Richardson
drew numerous portraits of him in both chalk and
graphite. Jonathan Junior's relaxed and unguarded
demeanour when sitting for his father make these
drawings a remarkably vivid sequence.

 The Richardsons shared artistic and literary
interests and they collaborated in the writing of two
books, *An Account of Some of the Statues, Bas-reliefs,
Drawings and Pictures in Italy, &c., with Remarks*,
published in 1722, which was based on Jonathan
Junior's travels abroad, and *Explanatory Notes and
Remarks on Milton's Paradise Lost* of 1734. Tellingly, on
the title pages of both books they appear as a sort of
composite author; respectively "Mr. RICHARDSON,
Sen. and *Jun*." and "J. RICHARDSON, Father and
Son". Jonathan Senior's great friend Alexander Pope
remarked on their harmonious existence and mutual
interests when he referred to them, in the context of
one of their co-authored books, as "worthy Mr. R. and
his son, – worthy two such lovers of one another, and
two such lovers of the fine arts".[31] A double portrait
which Richardson made of himself with his son
underlines their bond (fig. 9).

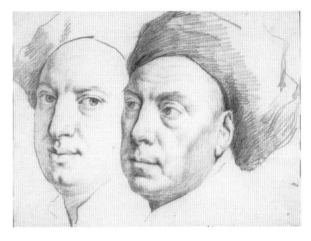

FIG. 9
Jonathan Richardson
Self-portrait with the artist's son, c. 1733–34
Red chalk on white paper, 299 x 409 mm
Montreal Museum of Fine Arts, Horsley
and Annie Townsend Bequest, DR.1959.117

Describing his son in a poem, 'Journey from
Whitchurch, Aug. 7–8, 1731', Richardson writes of their
delight in each other's company and mutual regard:

> My son, my other self, accompany'd,
> With him I joy to sit, to walk, to ride,
> Whether at home, or on the various way,
> He rules, intending only to obey,
> Delights, instructs me how to think and see,
> Whilst he alike is pleas'd and taught by me.[32]

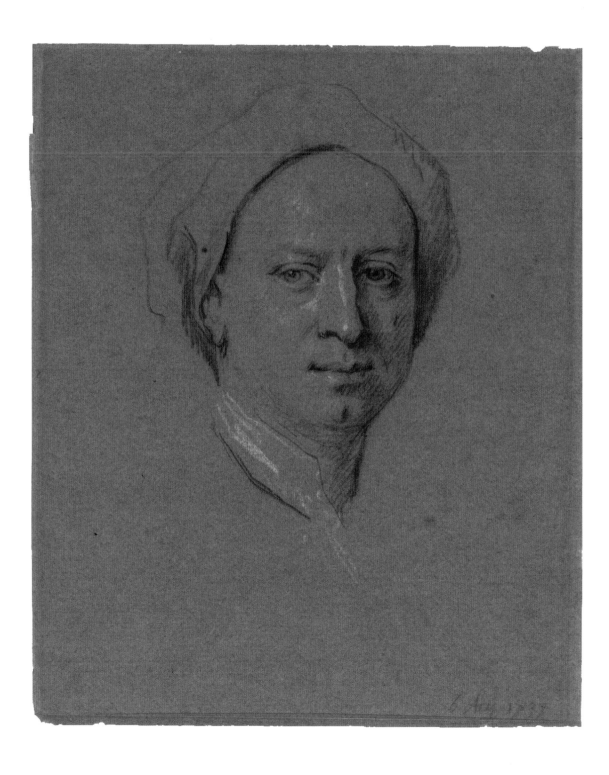

20

Portrait of Jonathan Richardson the Younger, 1734

Red, black and white chalk on blue paper, 330 × 257 mm
Inscribed on recto, lower right, in black chalk: *4 Oct' 1734*
The Courtauld Gallery, London, D.1952.RW.2439

PROVENANCE Richardson Senior (Lugt 2184, recto); presumably Richardson Junior; presumably his sale, 1772; Pole sale, 26 March 1930, bought Sir Robert Witt (Lugt 2228b, verso); by whom bequeathed to the Courtauld Institute of Art, 1952

Jonathan Junior benefitted from the education that his father had been denied, and his editorial notes on his father's poems are liberally seasoned with quotations from classical authors, although he admits that Richardson Senior was "entirely ignorant" of Greek and Latin.[33] Richardson was proud of his son's accomplishments, which he enjoyed vicariously, regarding himself to be "as it were Enlarg'd, Expanded, made Another Man by the Acquisition of My Son".[34] In his preface to their co-authored book, the 1734 *Explanatory Notes and Remarks on Milton's Paradise Lost*, Richardson explains their complementary talents: "My Son is my Learning, as I am That to Him which He has Not; We make One Man; and Such a Compound Man (what Sort of One Soever He is whom We make) May Probably, produce what no Single Man Can."[35] He goes on to make an extraordinary statement about their intertwined identity: "When therefore I, in my Own Person talk of Things which in my Separate Capacity I am known to be a Stranger to, let Me be Understood as the Complicated *Richardson*".[36]

It was rare for Richardson to use chalk for portraits of anyone other than himself and his son, and the number of informal portraits in this medium of Jonathan Junior provides further evidence of their harmonious domestic existence, while also suggesting that Richardson bracketed his son with himself. It also tends to confirm the proposition that he made chalk drawings exclusively in his own home. Portraits such as this, and cat. 19, of the younger Richardson looking self-assured, with a slight smile, present a contrast to the elder Richardson's more introspective self-portraiture and suggest a wider context in which it should be understood – he was a compulsive draughtsman, and as he wrote to a friend: "I Paint, Draw, Read, Write; I am Never Idle, nor (I hope) Unprofitably Employ'd".[37]

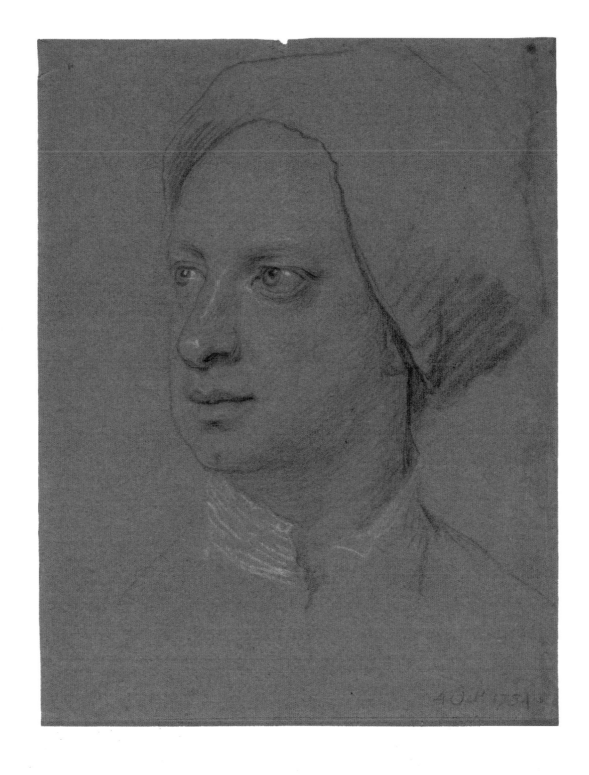

21

Portrait of Jonathan Richardson the Younger in profile, 1736

Graphite on vellum, 153 × 130 mm
Inscribed on the verso, lower right, in graphite: *8 May 1736*
Inscription, mounted below drawing, from old paper mount in pen and ink in an
18th- or 19th-century hand: *Richardson Junr*
The Courtauld Gallery, London, D.1952.RW.1465

PROVENANCE Richardson Senior (Lugt 2184, verso); Richardson Junior (Lugt 2170, recto);
presumably his sale, 1772; Hibbard; bought Sir Robert Witt (Lugt 2228b, verso); by whom
bequeathed to the Courtauld Institute of Art, 1952

This lively and characterful portrait portrays Jonathan Junior at the age of forty-two. It was relatively unusual for Richardson to represent anyone other than himself in profile; the small vellum portraits of his friends are mostly full-face. However, he exploited the expressive possibilities of the profile portrait when drawing particularly close friends, most notably Alexander Pope and Mrs Knapp.

Several of the poems in *Morning Thoughts* refer to Jonathan Junior, for instance 'Little sketch of my own joy in fine weather and country', which ends "If lovely were the season and the place, / My son was with me, who most lovely was", and another, which begins "I Love thee, son, my friend art thou".[38] However, during April 1736, the month before he drew this particular portrait, Richardson took the unusual step of addressing three solemn poems to his son: 'My Day Begun. To My Son', 'Latter Life. To My Son.

Ode' and 'Matter of Praise. To My Son'. Placed in the published volume near the end of the 'Morning Thoughts' section, they are among the latest in date to be included. These three poems have a valedictory air, especially 'Latter Life', which ends:

My soul is wrapt in harmony!
That thou the sweet delight may'st see,
My son, I leave my verse with thee.

I pour their blessings on thy head;
And if around the fragrance spread,
I shall live best when I am dead.[39]

With the ending of the poem-sequence Richardson is clearly thinking in terms of summing up his project of self-examination, and of handing the fruits to his beloved son.

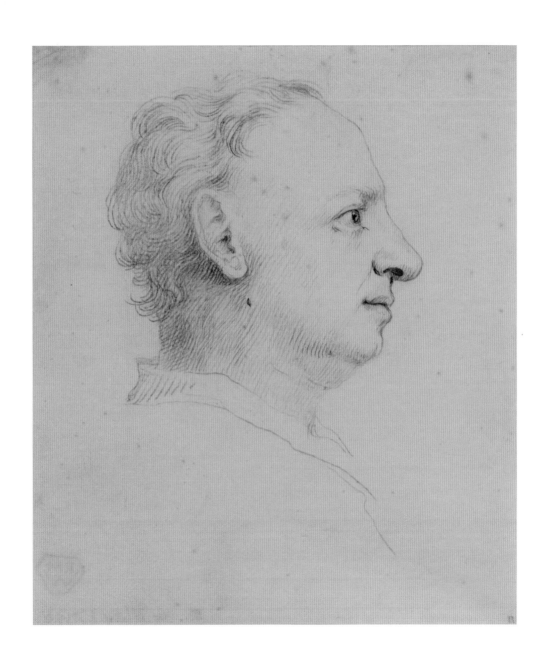

22

Portrait of Jonathan Richardson the Younger, 1736

Graphite on vellum, 151 × 126 mm
Inscribed on verso, upper centre, in pencil: *4 June 1736* and right centre, in pen and ink,
possibly in Jonathan Richardson Junior's hand: *Head Ach*
The Courtauld Gallery, London, D.1952.RW.1986

PROVENANCE Richardson Senior (Lugt 2184, verso); Richardson Junior (Lugt 2170, recto);
his sale, 1772; Sotheby's, date unknown; bought Sir Robert Witt (Lugt 2228b, verso); by whom
bequeathed to the Courtauld Institute of Art, 1952

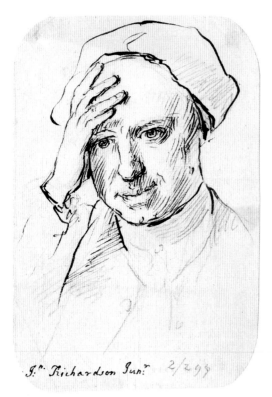

FIG. 10
Jonathan Richardson
Jonathan Richardson the Younger, c. 1736
Pen and ink over preparatory graphite on
cream paper, 167 x 113 mm (corners rounded)
The British Museum, London, 1989,1104.428

Although this drawing has been described as a self-portrait, the features represented are clearly those of Richardson the Younger, who can be distinguished from his father by his fuller lips, cleft chin, longer nose with bulbous tip and slightly protruberant eyes.[40] The double portrait reproduced here as fig. 9 makes a clear distinction between the two.

A drawing similar to this, in the British Museum – a rough sketch in pen and ink over preparatory graphite – represents Jonathan Junior holding his forehead and smiling in the same rueful way, although it shows him looking straight out at the viewer rather than off to the side (fig. 10). The pen drawing was perhaps the first draft of an idea which Richardson then developed into the more elegant pose, suggestive of profound thought, that appears in the vellum drawing (although the inscription, apparently in Richardson Junior's hand, *Head Ach*, brings it down to earth). Richardson's act of transforming a prosaic pose to a more dignified one, with overtones of the Augustan *philosophe*, is similar to that he performed in cat. 9, when he converted a profile self-portrait into an apparently low-relief bust, as it might appear on a coin or medal. As with his self-portraits, Richardson seems to have reserved his more playful impulses for small drawings on vellum rather than the larger chalk studies.

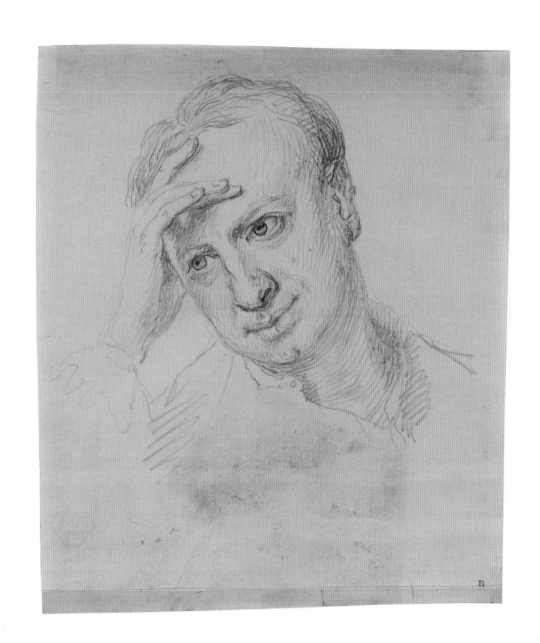

Notes

1 See Finsten 1993, p. 47.

2 Because this drawing and two others in the British Museum, London, with similar inscriptions by Walpole (1902,0822.40 and 1902,0822.41) are laid down (presumably by Walpole), it is not possible to see the versos.

3 Horace, *Satires*, II, I, 71. I am grateful to Bijan Omrani for his translation. A self-portrait by Richardson in the Yale Center for British Art, New Haven (B1975.4.673), is inscribed, apparently in Richardson Junior's hand, on the front of its old mount *Mitis Sapientia* (Gentle Wisdom) – words from the same passage in *Satires*.

4 Lugt 2184.

5 See Kerslake 1977, p. 229.

6 See Owens 2015b (forthcoming).

7 Richardson 1776, pp. 251 and 242.

8 "To Mr Pope, who said 'I had made more verses than he'", in Richardson 1772, p. 275.

9 I am grateful to Stephen Calloway for drawing this to my attention.

10 Addison 1726, p. 13.

11 Another example of a graphite-on-vellum drawing copied from an earlier oil painting is Huntington Library, Art Collections and Botanical Gardens, San Marino, 63.52.202. An inscription on the back records that it was *painted abt. 1707*.

12 Richardson 1776, pp. 294–95.

13 Richardson 1776, p. 183.

14 See White, Alexander and D'Oench 1983, no. 53, pp. 39–40. While Rembrandt's example as an inveterate self-portraitist

was doubtless a spur to Richardson's project, the absence of the original of which this drawing is a copy remains a barrier to assessing his specific intentions.

15 Composed 1–2 October 1735: Richardson 1776, pp. 126–27.

16 Finsten 1993, p. 47. See also Rogers 1993, p. 36.

17 Richardson 1715, pp. 141–42.

18 Richardson 1776, pp. 125–26.

19 Geest 2001–02, p. 31.

20 Gibson-Wood 1989; Gibson-Wood 2000, p. 98; and Gibson-Wood 2003, p. 161.

21 Jaffé 1994, no. 814, p. 106.

22 Jaffé 1994, no. 819, p. 109. Richardson's copy is British Museum, London, 1902,0822.52.

23 Editorial note by Jonathan Richardson Junior, in Richardson 1776, p. xv.

24 Richardson 1719, I, p. 196.

25 Another self-portrait etching of 1738 is lettered with the couplet *These Features must in Silent Darkness Rot. / No Reason why my Heart shou'd be Forgot.*, and was perhaps created as an alternative frontispiece for *Morning Thoughts*, or even made for a proposed second volume (see, for example, British Museum, London, Q,1.144). I am grateful to Bryony Bartlett-Rawlings for this suggestion.

26 *A catalogue of the large and capital collection of prints and drawings of Jonathan Richardson Esq* (London 1772), lot 25 of day five; in 'The art world in Britain 1660 to 1735', at http://artworld.york.ac.uk;

accessed 29 December 2014. "Reverses" (counterproofs) are also recorded in lots 21, 22 and 23 of day five and lot 18 of day six. The present counterproof was presumably included in either lot 23 or lot 25 of day five.

27 *Portrait of Alexander Pope*, in Cornell University Library, Ithaca, Hibbert-Ware album, no. 4600. See Wimsatt 1965, pp. 159–60 and Eddy 1988, p. 23.

28 See Kerslake 1977, no. 1693, p. 229. The primary drawing, a profile self-portrait, is National Portrait Gallery, 1693; the related offset is British Museum, 1872,1012.3381.

29 Richardson 1715, p. 179.

30 See file note in Courtauld Gallery: "Witt: 'From frame – *Bought at Mulready's Sale. Said to be a portrait of Sir J. Thornhill by Hogarth*'".

31 Sherburn 1956, II, pp. 140–41.

32 Richardson 1776, p. 317.

33 Editorial note to 'To the Lark: An Arabian Thought', in Richardson 1776, p. 168.

34 Richardson Senior, in Richardson Senior and Junior 1734, pp. clxviii–clxix.

35 Richardson Senior and Junior 1734, p. cxli.

36 Richardson Senior and Junior 1734, p. cxli.

37 Letter to Ralph Palmer, 6 October 1735, British Library, London, MS 71245 D.

38 Richardson 1776, pp. 180 and 305.

39 Richardson 1776, pp. 154–55, at p. 155.

40 Gibson-Wood 1994, pp. 209–10; Gibson-Wood 2000, p. 122.

Select bibliography and list of works cited

Joseph Addison, *Dialogue upon the Usefulness of Ancient Medals, especially in relation to the Latin and Greek Poets*, London 1726

David Alexander, 'The Historic Framing of Prints: the Treatment of English Prints in the Eighteenth Century', in Nancy Bell (ed.), *The Historic Framing and Presentation of Watercolours, Drawings and Prints*, Worcester 1997

Bryony Bartlett-Rawlings, 'Jonathan Richardson as an Etcher', *Print Quarterly* (forthcoming, 2015)

C.H. Collins Baker, 'Some Drawings by Jonathan Richardson in the Witt Collection', *The Connoisseur*, LXXIII, December 1925, pp. 195–202

Donald D. Eddy, *The Drawings of Jonathan Richardson at Cornell: Celebrating the Tercentenary of the Birth of Alexander Pope*, Ithaca, NY 1988

Jill Finsten, 'A Self-Portrait by Jonathan Richardson', in *The J. Paul Getty Museum Journal*, XXI, 1993, pp. 43–54

Simone von der Geest, '"To Self. Unfinished sketch": Jonathan Richardson's Series of Self-portrait Drawings 1728–36', *Object*, IV, 2001–02, pp. 25–43

Simone von der Geest, *The Reasoning Eye: Jonathan Richardson's Portrait Theory and Practice in the Context of the English Enlightenment*, PhD thesis, University College London 2005

Carol Gibson-Wood, 'Jonathan Richardson, Lord Somers's Collection of Drawings, and Early Art-Historical Writing in England', *Journal of the Warburg and Courtauld Institutes*, LII, 1989, pp. 167–87

Carol Gibson-Wood, 'Jonathan Richardson as a Draftsman', *Master Drawings*, XXXII, 3, 1994, pp. 203–29

Carol Gibson-Wood, *Jonathan Richardson: Art Theorist of the English Enlightenment*, New Haven and London 2000

Carol Gibson-Wood, '"A Judiciously Disposed Collection": Jonathan Richardson Senior's Cabinet of Drawings', in Christopher Baker, Caroline Elam and Genevieve Warwick (eds.), *Collecting Prints and Drawings in Europe, c.1500-1800*, Aldershot 2003, pp. 155–70

James Hall, *The Self-Portrait: A Cultural History*, London 2014

Michael Jaffé, *The Devonshire Collection of Italian Drawings: Venetian and North Italian Schools*, London 1994

John Kerslake, *Early Georgian Portraits*, London 1977

Lawrence Lipking, *The Ordering of the Arts in Eighteenth-Century England*, Princeton, NJ 1970

Roger Lonsdale, 'Jonathan Richardson's *Morning Thoughts*', in D.L. Patey and T. Keegan (eds.), *Augustan Studies: Essays in Honour of Irvin Ehrenpreis*, Newark, London and Toronto 1985, pp. 175–94

Fritz Lugt, *Les Marques de Collections de Dessins & d'Estampes*, at http://www.marquesdecollections.fr; accessed 1 May 2015

John Rupert Martin, *The Portrait of John Milton at Princeton and its place in Milton Iconography*, Princeton, NJ 1961

Patrick Noon, *English Portrait Drawings & Miniatures*, New Haven 1979

Susan Owens, *The Art of Drawing: British Masters and Methods Since 1600*, London 2013

Susan Owens, 'A note on Jonathan Richardson's working methods', *Burlington Magazine*, CLVII, 1348, July 2015 [2015a]

Susan Owens, 'Jonathan Richardson and Mrs Knapp', *Times Literary Supplement* (forthcoming, 2015 [2015b])

Gudrun Raatschen, 'Plaster Casts of Bernini's Bust of Charles I', *Burlington Magazine*, CXXXVIII, 1125, December 1996, pp. 813–16

Jonathan Richardson, *An Essay on the Theory of Painting*, London 1715

Jonathan Richardson, *Two Discourses. I. An Essay on the whole Art of Criticism as it relates to Painting. Shewing how to judge I. Of the Goodness of a Picture; II. Of the Hand of the Master; and III. Whether 'tis an Original, or a Copy. II. An Argument in behalf of the Science of a Connoisseur; Wherein is shewn the Dignity, Certainty, Pleasure, and Advantage of it*, London 1719

Jonathan Richardson, *Morning Thoughts: Or Poetical Meditations, Moral, Divine and Miscellaneous. Together with several other Poems on Various Subjects*, London 1776

Jonathan Richardson Senior and Jonathan Richardson Junior, *Explanatory Notes and Remarks on Milton's Paradise Lost*, London 1734

Malcolm Rogers, *Master Drawings from the National Portrait Gallery*, London 1993

George Sherburn (ed.), *The Correspondence of Alexander Pope*, 5 vols., Oxford 1956

Kim Sloan and Stephen Lloyd, *The Intimate Portrait: Drawings, Miniatures and Pastels from Ramsay to Lawrence*, exh. cat., Scottish National Portrait Gallery, Edinburgh, and British Musuem, London 2008

Gordon William Snelgrove, *The Works and Theories of Jonathan Richardson Senior*, PhD thesis, Courtauld Institute, London 1936

George Vertue, *Prints. King Charles I. and the heads of the noble earls, lords, and others, who suffered for their loyalty in the rebellion and civil-wars of England. With their characters engraved under each print, extracted from Lord Clarendon. Taken from original pictures of the greatest masters, many of them by Sir Anthony Van Dyke, and all the heads accurately engraved by Mr Geo. Vertue*, London 1746

George Vertue, 'Vertue's Note Book', *Walpole Society*, XX, 1933–34

Horace Walpole, *Anecdotes of Painting in England; with some Account of the principal Artists; And incidental Notes on other Arts; Collected by the late Mr. George Vertue; And now digested and published from his original MSS. By Mr. Horace Walpole*, volume IV, 2nd edition with additions, London 1782

Richard Wendorf, 'Jonathan Richardson: The Painter as Biographer', *New Literary History*, XV, 3, 1984, pp. 539–57

Christopher White, David Alexander and Ellen D'Oench, *Rembrandt in Eighteenth Century England*, exh. cat., Yale Center for British Art, New Haven 1983

W. K. Wimsatt, *The Portraits of Alexander Pope*, New Haven and London 1965